THE WATERS OF AMERICA

THE WATERS OF AMERICA
19th-Century American Paintings of Rivers, Streams, Lakes, and Waterfalls

An exhibition presented by
The Historic New Orleans Collection
Stanton Frazar
Director

with the cooperation of
The New Orleans Museum of Art
E. John Bullard
Director

Honorary Chairman of the Exhibition
The Honorable Daniel J. Terra
United States Ambassador-at-large for Cultural Affairs

The exhibition and catalogue were funded through
The Kemper and Leila Williams Foundation
New Orleans, Louisiana

Cover and Title Page Illustration
Niagara Falls, ca.1869–70, by Albert Bierstadt
oil on canvas, 25 x 20 in.
The Thomas Gilcrease Institute of American History and Art
Tulsa, Oklahoma

THE WATERS OF AMERICA

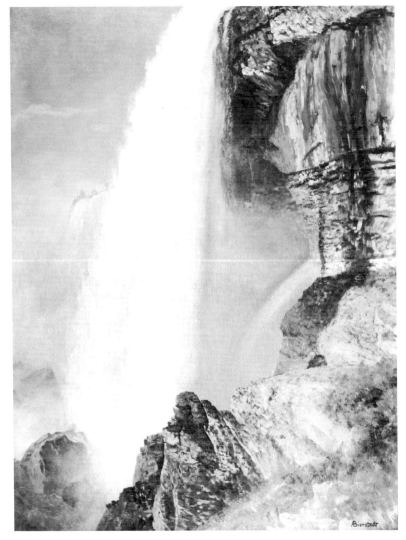

19th-Century American Paintings
of Rivers, Streams, Lakes, and Waterfalls

UNIVERSITY OF TOLEDO
LINCOLN - CIVIL WAR
& 19TH CENTURY COLLECTION

May 6–November 18, 1984
To Commemorate the 1984 Louisiana World Exposition

Essay by
John Wilmerding
Exhibition coordinated by
John A. Mahé II

THE HISTORIC
NEW ORLEANS
COLLECTION

NEW ORLEANS
MUSEUM OF ART

Stanton Frazar
Director

E. John Bullard
Director

Board of Directors

Benjamin W. Yancey, *President*

Ernest C. Villeré G. Henry Pierson, Jr.

Mrs. William K. Christovich John A. Rodgers III

Contents

Lenders to the Exhibition

Albany Institute of History and Art,
　　Albany, New York

Albright-Knox Art Gallery, Buffalo, New York

Jay P. Altmayer, Mobile, Alabama

Amon Carter Museum, Fort Worth, Texas

Buffalo Bill Historical Center, Cody, Wyoming

California Historical Society,
　　San Francisco/Los Angeles, California

Cincinnati Art Museum, Cincinnati, Ohio

The Corcoran Gallery of Art, Washington, D.C.

Crocker Art Museum, Sacramento, California

The Currier Gallery of Art,
　　Manchester, New Hampshire

The Detroit Institute of Arts, Detroit, Michigan

Diplomatic Reception Rooms,
　　Department of State, Washington, D.C.

The Dossin Great Lakes Museum,
　　Detroit, Michigan

Duluth Public Library, Duluth, Minnesota

Everson Museum of Art, Syracuse, New York

The Thomas Gilcrease Institute of
　　American History and Art, Tulsa, Oklahoma

Mr. and Mrs. William E. Groves,
　　New Orleans, Louisiana

The Haggin Museum, Stockton, California

The Hall Farm Group, North Bennington, Vermont

Heckscher Museum, Huntington, New York

Henry Art Gallery,
　　University of Washington, Seattle, Washington

Hirschl & Adler Galleries, Inc.,
　　New York, New York

The Historic New Orleans Collection,
　　New Orleans, Louisiana

The Hudson River Museum, Yonkers, New York

IBM Corporation, Armonk, New York

Indiana University Art Museum,
　　Bloomington, Indiana

Jones Library, Inc.,
　　Amherst College, Amherst, Massachusetts

Justina and Frank Keller, New Orleans, Louisiana

Mr. and Mrs. Arthur A. Lemann, Jr.,
　　Donaldsonville, Louisiana

Memphis Brooks Museum of Art,
　　Memphis, Tennessee

The Metropolitan Museum of Art,
　　New York, New York

The Minneapolis Institute of Arts,
　　Minneapolis, Minnesota

Mint Museum, Charlotte, North Carolina

Montclair Art Museum, Montclair, New Jersey

Munson-Williams-Proctor Institute,
　　Utica, New York

Museum of Art, Carnegie Institute,
　　Pittsburgh, Pennsylvania

Museum of Fine Arts, Boston, Massachusetts

Museum of Fine Arts, Museum of New Mexico,
　　Santa Fe, New Mexico

National Gallery of Art, Washington, D.C.

National Museum of American Art,
　　Smithsonian Institution, Washington, D.C.

The Newark Museum, Newark, New Jersey

New Orleans Museum of Art,
　　New Orleans, Louisiana

The New-York Historical Society,
New York, New York
The Oakland Museum, Oakland, California
The Pennsylvania Academy of the Fine Arts,
Philadelphia, Pennsylvania
Philadelphia Museum of Art,
Philadelphia, Pennsylvania
Phoenix Art Museum, Phoenix, Arizona
The Saint Louis Art Museum, St. Louis, Missouri
San Antonio Museum Association,
San Antonio, Texas
San Antonio Public Library System,
San Antonio, Texas
Smith College Museum of Art,
Northampton, Massachusetts

Ira Spanierman, Inc., New York, New York
Terra Museum of American Art, Evanston, Illinois
Utah State Fine Art Collection,
Utah Arts Council, Salt Lake City, Utah
Wadsworth Atheneum, Hartford, Connecticut
Walker Art Center, Minneapolis, Minnesota
Washington University Gallery of Art,
St. Louis, Missouri
Westmoreland Museum of Art,
Greensburg, Pennsylvania

American Waters

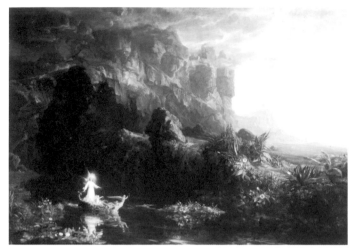

Childhood (52⅞ x 77⅞ in.)

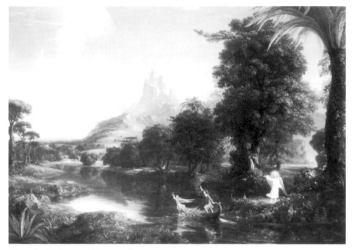

Youth (52⅞ x 76¾ in.)

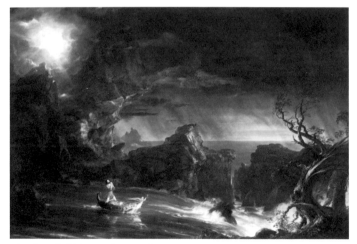

Manhood (52⅞ x 79¾ in.)

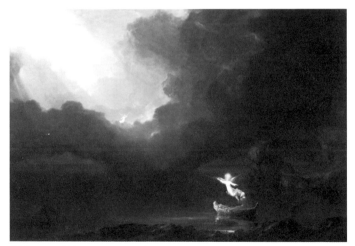

Old Age (52½ x 77¼ in.)

Thomas Cole
The Voyage of Life 1842
oil on canvas
National Gallery of Art, Washington, D.C.
Ailsa Mellon Bruce Fund 1971

American Waters: The Flow of Imagination

Without water, Thomas Cole asserted, "every landscape is defective."[1] America's premier painter of native scenery was speaking of an essential physical and psychological component of the American experience. Rivers especially carry the story of our voyage of existence. Water, the first element, defined the vast space of the early explorers' transatlantic crossings. Subsequently, rivers provided, through their harbors and inland courses, welcoming places of settlement and routes of commerce. Early on, America's waterways were places of fighting and of leisure; they were lines of transportation and forces of energy in the coming of industrialization.

In varying combinations rivers have always appealed for their scenic beauty and commercial potential, and it is no surprise that many of the world's capital cities are sited on rivers: London, Paris, Moscow, Washington, Rome. In America's development we are drawn to splendid river settings for cities of all sizes: Seattle, New York, Philadelphia, St. Louis, Chattanooga. Boston harbor marks the confluence of three rivers—the Charles, Mystic, and Neponset. San Francisco sits at the mouth of a great inland bay, while New Orleans oversees the expansive joining of the father of waters with the mother sea.

The original water voyage brought explorers and would-be conquerors and settlers to a new landfall scalloped by river mouths. The mythology of westward travel in empire's course was borne forward by the multiple possibilities of entering this undefined continent. The search for a northwest passage to India was of course the most enduring fixation of early voyagers, and the belief in a westward-flowing river beyond the Appalachians continued for over a century.[2] The first encounter by Columbus with the tides of fresh water must have been an exhilarating, revelatory experience, for here was evidence at once of destination and future possibility.[3]

Initially, the mouths of rivers provided harbors of refuge in which food might be found and settlements established. The most familiar of early maps and drawings done of the New World, such as those by Jacques Le-Moyne and John White, vividly portray activities along the middle and southern Atlantic coastline. White's maps indicate the location of villages and the configurations of inland terrain, ever vaguer and more imagined moving inland, while his watercolors give us early mementos of local flora, fauna, and Indian life. LeMoyne's famous image of *René de Laudonniere with Chief Athore*, 1585, now in the New York Public Library, is a colorful rendering of old and new worlds meeting alongside a decorated column at the mouth of the St. John's River in north Florida. At their feet is arranged an abundant still life of nature's bounty, emblems of the continent's rich produce and prophecy.

Once ashore, visitors soon discovered hostile conditions or resistant inhabitants. Travel was impeded by mountain ranges and the growing awareness of an endlessly expanding unknown terrain. Such factors made river travel seem both easy and necessary. Rivers permitted America's early settlers mobility, and thus the continent's waterways were to carry the flow of both exploration and development. In the summary phrases of one historian,

> The river is a defining agent in the metamorphosis of colonies to republic, serving as entrance or border but always as a symbol of what might be obtained beyond, whether a more fertile land or a water route to India.[4]

It is important to stress that this movement in time and space was as much mythical as practical. Beyond its functional purpose as a mode of travel, the river also assumed a masculine identity as it penetrated the virgin interior and fathered the conception of a new world.[5]

1. Thomas Cole, "Essay on American Scenery," 1835, quoted in John W. McCoubrey, ed., *American Art, 1700-1960, Sources and Documents* (Englewood Cliffs, N.J., 1965), 103.
2. See John Seelye, *Prophetic Waters: The River in Early American Life and Literature* (New York, 1977), 84, 89.
3. See *ibid.*, 11.
4. *Ibid.*, 7.
5. See *ibid.*, 79.

The great rivers of the middle Atlantic and New England coasts were among the first to draw attention and praise as passageways of notable scenic beauty. As early as 1638 one visitor pronounced, "If you would know the garden of New England, then must you glance your eye upon Hudson's river, a place exceeding all yet named."[6] That river, like its neighboring finger to the east, the Connecticut, was a long artery flowing from the wilderness far to the north. These two lines of geography particularly were to become major forces in both the regional development and artistic interest of the young republic. As the coastline was gradually populated and civilized during the colonial period, travelers were lured to spots of special natural beauty. During the decades following the American Revolution the country's newfound power and opportunity stimulated new waves of European immigrants, many fleeing the problems of the Industrial Revolution and the Napoleonic Wars at home. In the years around the turn of the century, a significant number of artists came to America, and their attention to the fresh scenic wonders of the continent in effect resulted in our first extensive flourish of landscape painting.

Among the better-known foreign painters of this period were Michele Felice Corné, who came from Elba to work in Salem, Massachusetts; the English-born artist Francis Guy, active in Brooklyn, New York; and Thomas Birch and Robert Salmon, at work respectively around Philadelphia and Boston. Although each of these last two did paint an occasional river view near his city's environs, they remained essentially delineators of coastal activities or historical subjects. Of those émigrés who executed a number of inland river views, the most significant were William Groombridge in Philadelphia, the Robertson brothers, Archibald and Alexander, working north of New York along the upper Hudson valley, and Joshua Shaw, who undertook extensive journeys along the Atlantic seaboard. In varying ways this group of artists imported the picturesque conventions of eighteenth-century English painting. For example, Groombridge carefully modulated

his feathery trees to punctuate and frame his views of Pennsylvania country estates situated along the Schuylkill River. Their gauzy softness of form and light infused the identifiable sites he painted with an idealizing tone. Shaw only occasionally depicted actual settings, more often preferring to compose imaginary landscape and river scenes. The fine pen and pencil drawings of the Robertsons, based on their voyages along the Hudson, are perhaps the most specific renderings from this period.

In any case, by the first quarter of the nineteenth century, the young nation had developed a sufficient sense of self-awareness that its physical landscape called for full delineation and its spiritual substance for metaphorical articulation. Out of these earlier aspirations now emerged America's first full-scale landscape movement, appropriately titled by a key waterway, the Hudson River School. The leading figures of this group, Thomas Doughty, Thomas Cole, and Asher B. Durand, were all to include the river as a key component of their pictorial repertoire. As the oldest, Doughty was actively painting landscape views by the early 1820s, usually according to one of three formulas: *from nature, from recollection,* or *composition.* The first were ordinarily sketched on the spot and maintained their specificity in the final rendering on canvas. The second category allowed more manipulation and enhancement as the artist modified nature through the filter of imagination, while the last represented fully fanciful invention at the other end of the range. Almost always, the presence of water in a stream or pond was a central ingredient of both design and meaning.

Cole articulated the logic of nature in his 1835 *Essay on American Scenery,* in which he asserted that on the highest level, "wilderness is YET a fitting place to speak of God," and following from that, was "a source of delight and improvement."[7] The contemplation of scenery, in turn, meant that nature's pilgrim needed to appreciate the different expressive functions of each landscape element. For example, the mountains of America were noted for their rugged purity and emphasized a distinguishing

6. Quoted in *ibid.,* 207.

7. Thomas Cole, "Essay on American Scenery," 100.

aspect of new world nature. Water was one of the next most important features, because, tranquil and transparent, it invited meditation, and, in motion over cataracts or waterfalls, it became the sublime "voice of the landscape." Trees and sky completed the basic categories. But it was only water which served as mirror to the sky and to the soul, and it was water which made visible as well as audible the "silent energy of nature."[8]

Cole was as eloquent in practice as he was in theory. Preeminent in his generation, he brought the painting of literal as well as imaginative landscape to the center stage of American art. Both the Hudson and the Connecticut valleys inspired him to compose views capturing the immediate physical drama of place, along with an idealized sense of time's primordial passage. Particularly effective was his device of the elevated point of view, as in *Sunny Morning on the Hudson* (Museum of Fine Arts, Boston, Massachusetts) and *The Oxbow on the Connecticut River* (The Metropolitan Museum of Art, New York, New York), both celebrations of fact and spirit. Indeed, Cole was unrestrained in praising the respective characteristics of each valley: "The Hudson for natural magnificence is unsurpassed. . . . [It] has . . . a natural majesty, and an unbounded capacity for improvement by art."[9] By contrast,

> In the Connecticut we behold a river that differs widely from the Hudson. . . . the imagination can scarcely conceive Arcadian vales more lovely or more peaceful than the valley of the Connecticut.[10]

At the same time that Cole was recording his responses to actual sites, he was also pursuing ambitious imaginative compositions, the most relevant being the two versions of his *Voyage of Life* series of 1840 and 1842 (respectively, Munson-Williams-Proctor Institute, Utica, New York, and National Gallery of Art, Washington, D.C.). Like the great *Course of Empire* group which Cole executed in 1836, this was conceived and composed as a coherent series of pictures. In this instance, *The Voyage of Life* was a sequence of four paintings, unified by the river flowing through each. A purely invented subject

devoted to the passage of human and natural time, it consisted of four stages: *Childhood, Youth, Manhood,* and *Old Age.* Cole not only linked them together with the idea of flowing water, but also painted them the same size and included the presence of a figure seen respectively in four moments of age. Correspondingly, the growth of nature and condition of light change from scene to scene, shifting from verdant brightness to increasing drama and contrast. Cole carries us from the symbolic earth cave and clarity of early morning at birth to the open ocean and stormy heavens of the concluding image. Cole accompanied his canvases with an explicit description for his public. In *Childhood,* for example, "the dark cavern is emblematic of our earthly origin, and the mysterious Past," while in *Youth* "the stream now pursues its course through a landscape of wider scope,"[11] a word referring equally to the physically expansive vista and symbolic aspirations of the figure. "Trouble is characteristic of the period of Manhood," while the final painting depicts "the last shore of the world."[12]

To carry out his meaning Cole cleverly composed his landscapes so that the river made a series of S-curves within each frame, allowing the eye to follow its course out of the foreground of one and into the background of the next. This served the obvious purpose of visual continuity and embodied the lofty allegory of the inevitable flow of time. In sum, the series was Cole's purest philosophical statement regarding the spiritual content of American nature.

But Cole remained equally the master of the specific landscape, and his views of the Hudson valley also established formulas that were emulated by younger artists of the next generation. In the middle decades of the nineteenth century, painters sought a wider range of both interpretation and geography, as Cole himself had anticipated:

> Nor ought the Ohio, the Susquehannah [sic], the Potomac, with their tributaries, and a thousand others, be omitted in the rich list of the American rivers—they are a glorious brotherhood.[13]

8. *Ibid.,* 104, 105.
9. *Ibid.,* 105, 106.
10. *Ibid.,* 106.

11. Quoted in Louis Legrand Noble, *The Life and Works of Thomas Cole* (Cambridge, Mass., 1964), 214, 215.
12. *Ibid.,* 216.
13. Cole, "American Scenery," 106.

5

During this early development of the Hudson River School, represented by Cole's maturity and carried on by others traveling more widely, interest concentrated on, we might say, the "prose" of nature. That is, painters sought to describe the accumulated details of a scene in all their density and varied texture. The eye passed through all these natural facts as if experiencing a narrative of actual or implied activity. To this end, the artist alerted his viewer to the changing colors of foliage, the erosion of rocks, the breaking of tree limbs, and especially water moving. The waterfall became a favorite subject, seen at its most characteristic in John Frederick Kensett's renderings of Bash Bish Falls, to convey the energies of American nature. Niagara, of course, was the preeminent and enduring pilgrimage site of the nineteenth century, painted early on by John Trumbull and John Vanderlyn, then by Cole and almost all of his associates, and later by such American impressionists as John Twachtman and George Inness. As Cole asserted, and his pupil Frederic Church made definitive, Niagara was "that wonder of the world!—where the sublime and the beautiful are bound together in an indissoluble chain."[14]

By the late 1840s there was increasing attention to what we might now describe, by contrast, as the "poetry" of nature, that is to say, its distillation for the eye and mind to contemplate. Less overt action was depicted, landscape elements were often stilled, and visual density yielded more to spacious openness. These were all aspects which would come together to define that next stage of American landscape painting now termed luminism. Again, Cole anticipated the spiritual significance of the lake for his colleagues and successors, as "a most expressive feature: in the unrippled lake, which mirrors all surrounding objects, we have the expression of tranquility and peace."[15] The luminist landscape of mid-century would favor the spacious panorama and the clear mirror of open surfaces of water. Painters especially turned now for subjects to lakes and expanses of wide rivers. Typical were Kensett's serene image of *Shrewsbury River* and the idealized com-

positions of George Caleb Bingham's Mississippi and Missouri river series.

Bingham's supreme boatman series, painted between 1845 and 1855, are notable for their perfectly calculated compositions, often employing clear geometries of line and plane and building up from solid horizontals into pyramidal figure groups. This sense of orderly design was exactly in keeping with the radiant light that permeates his backgrounds and the calm quiet of his river surfaces, all conveying a wilderness world of tranquility and harmony. Not merely scenes of trade or travel, these expressed man's union with his environment and an implication of productive well-being. Set at mid-century, as well as in the middle of the country, Bingham's imagery captures a culminating period of high noon in the American heartland. It is worth recalling at this point that the same great rivers would similarly inspire some of our greatest imaginative literature in Mark Twain's novels, *The Adventures of Huckleberry Finn* and *Life on the Mississippi*. In these, the timeless flow of the river allowed examination of the central themes in American geography and sociology, namely the relationships between north and south and between white and black.

If the serenity of the open river served as one mode for an American vision of optimism and promise, so, too, did the broad expanses of inland lakes. For example, one thinks of Jasper Cropsey's exuberance in painting the sweep of Greenwood Lake, New Jersey, and of the many artists journeying to Lake George in upstate New York, or Albert Bierstadt's dramatizing the hopeful glory of a rainbow arching over Jenney Lake in the west. In particular, during the middle decades of the nineteenth century Lake George attracted such artists as David Johnson, John F. Kensett, and Martin Johnson Heade, and their visions of its beauty were echoed well into the twentieth century in the respective images of Georgia O'Keeffe and Alfred Stieglitz. Among the earlier group only Heade gave any hint of anxiety and turbulence. Within the essentially peaceful expanse of his view of *Lake George*, 1862 (Mu-

14. *Ibid.*, 105.
15. *Ibid.*, 103.

6

seum of Fine Arts, Boston Massachusetts) there is a quality of vacuum-like dryness, as if the barometer were unsettled and predicting change as yet unseen. In many ways such as this, American painters were able to infuse their responses to landscape with deep currents of feeling.

Heade is also important to the discussion at this juncture because of his special and virtually individual treatment of the marsh landscapes along the New England and mid-Atlantic coasts. First at Newport, Rhode Island, then Newburyport, Massachusetts, and later in New Jersey and Florida, Heade painted dozens of views in the saltwater marshes. This was a terrain distinctive for being both land and water depending on the ever-alternating tides. The usually undulating rivers wind back and forth to the open shore, themselves a mixture of fresh and salt water. Essentially flat expanses, they exemplified the luminist vision of spacious beauty. At the same time their dual nature and constant flux also spoke to an America in the 1860s and '70s of increasingly uncertain change and transformation.

The heroic interpretation of American nature culminated in the 1870s as painters discovered the breathtaking panoramas in the mountain valleys of western ranges, especially the Rockies. In gigantic canvases Thomas Moran sought to capture the scale and grandeur of Yellowstone as Albert Bierstadt did of Yosemite. Like Cole before them, they felt they were entering primeval nature and, by extension, into the presence of the Creator. Never had water in its various mainfestations—as ice and snow on the mountain peaks or as glinting liquid in the valley streams—seemed so pure a manifestation of life-giving force. Indeed, Fitz Hugh Ludlow, Bierstadt's companion and narrator of their first journey into Yosemite, later wrote that they felt they were "going to the original site of the Garden of Eden." [16] Once in the valley itself, and with the distant view opening before them, Ludlow described the sensation of

> breaking into the sacred closet of Nature's self-examination. . . . Earth below was as motionless as the ancient heavens above, save for the shining serpent of the Merced, which silently threaded the middle of the grass, and twinkled his burnished back in the sunset wherever for a space he glided out of the shadow of the woods. [17]

This was probably the last generation which saw nature as holding the potency of First Artist.

By contrast, during the last quarter of the nineteenth century the river landscape in America became increasingly a setting of encroaching industrialization. Many painters, whether working in a realist or impressionist mode, nonetheless retained a poignant sense of the Arcadian past. Thomas Eakins was perhaps the most forthright in addressing contemporary scenes and subjects, including his early series of pictures devoted to rowing on the Schuylkill River in Philadelphia. In these, the river is clearly part of the modern cityscape, even if only hinted at in the cropped presence of bridges seen in the background or sides of several canvases. In showing himself and his friends, most familiarly Max Schmitt or the Biglin brothers, rowing their sculls, Eakins was in part celebrating human discipline and coordination. But through the mathematical ordering of his architectural designs, he also conveys a belief in the integral relation between man and nature and the parts of a whole all working organically together. But he is further conscious in many of these pictures of the actual fact and metaphoric implication of time's passage. The rowers pass through light and shadow. They are caught in transitional moments of action, as if stopped photographically. Often a bright haze suffuses the whole, though as specific as the time and place seem, we ultimately feel the truth that neither motion nor change can be stopped. *Max Schmitt in a Single Scull*, 1871 (The Metropolitan Museum of Art, New York, New York) is particularly relevant, for the golden sunlight and leafless trees suggest an hour and a season in passage. The steamboat and the iron bridge in the distance are prominent signs of a new era's technology. The river itself is the central element of unseen flux. Thomas Cole's *Voyage of Life* has now been transmuted from allegory to actuality.

16. Fitz Hugh Ludlow, *The Heart of the Continent*, 1870, quoted in Richard Shafer Trump, "Life and Works of Albert Bierstadt," (Ph.D. dissertation, The Ohio State University, 1963), 112.

17. *Ibid.*, 118.

The new iron bridges of the last half of the century also figure prominently in the work of the American impressionists. Following the example especially of Monet's numerous views along the Seine in the Parisian suburbs, these painters addressed anew the juncture of nature and civilization. As city populations expanded and the railroad made travel more convenient, the movement of people and things shifted from the rivers themselves to the bridges across them. For a time American painters saw romantic beauty in the power and design of bridges, and, at least in the hands of the impressionists, their delicate tracery provided colorful abstract patterns for their compositions. One thinks of examples by John Twachtman and specifically *The Red Bridge*, 1895 (The Metropolitan Museum of Art, New York, New York) by J. Alden Weir.

This tradition continues into the early twentieth century in the work of the Ash Can School. In Ernest Lawson's paintings of the Harlem River bridge and George Bellows's views of the Hudson River palisades, we witness the enthusiasm of a younger generation for what they considered the energies and dynamism of America in a new century. Now it was no longer the pastoral seclusion of the upper Hudson valley that appealed, but rather the wide and deep mouth of the waterway as it passed the modern landscape of the world's greatest city. The urban spirit, the drama of technology, and the accelerated pulse of contemporary life all fused in the bold abstractions of Joseph Stella's *Bridge* of 1922 (The Newark Museum, Newark, New Jersey). No less in the twentieth century than in the sixteenth, American rivers have served as lines of energy—for self-discovery and self-definition.

John Wilmerding
Deputy Director
National Gallery of Art
Washington, D.C.

Catalogue of the Exhibition

John A. Mahé II
Exhibition Coordinator
Curator, The Historic New Orleans Collection

Lisette C. Oser
Exhibition Registrar

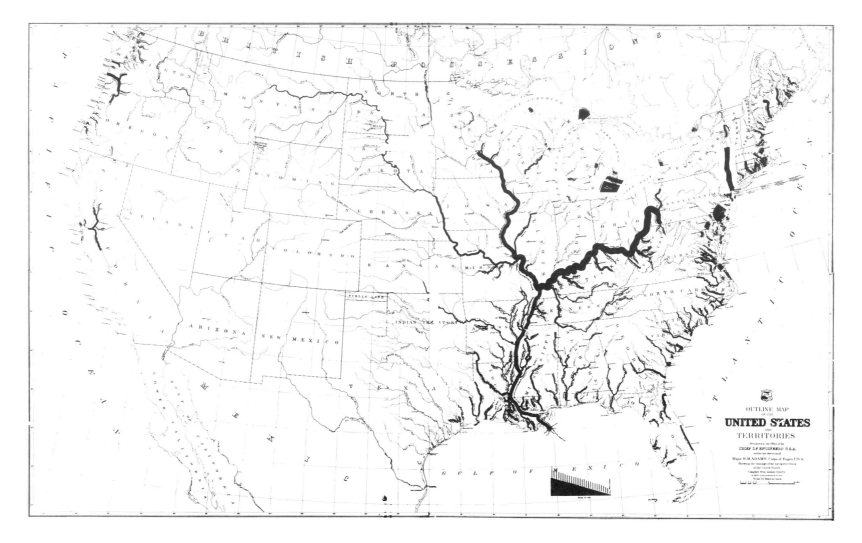

Map of American Waterways, 1894
The Historic New Orleans Collection

Hudson River, the Catskills, and Environs

The Hudson River begins at Lake Tear in the Adirondack Mountains in upper New York State and, after 315 miles, empties into the Atlantic Ocean at New York City. In its passage the Hudson flows past splendid estates on the east bank, built facing the scenic beauty of the Catskill Mountains across the river.

The Dutch settled the Hudson Valley, following Henry Hudson's 1609 discovery of the river. The colony was taken by the English in 1664 and named New York. Early settlers seeking land traveled up the Hudson to the Mohawk and then west into the interior of the state. The Hudson and Mohawk valleys became important agricultural regions, and waterfalls on the two rivers provided power for manufacturing. The successful journey of Robert Fulton's steamboat *Clermont* up the Hudson River to Albany in 1807 inaugurated the steamboat era. Farm produce and manufactured goods were transported down the Hudson to New York City, making it a leading port and trade center.

New York City also became a cultural magnet where serious professional artists set up their studios. They traveled up the Hudson, following the example of Thomas Cole, one of America's leading painters. Impressed with the beauty along the river, Cole set up a studio at Catskill, New York, where the river joined Catskill Creek. In an era of Romanticism, this region provided artists with a vision of unspoiled wilderness. Cole and his followers, today called the Hudson River School, experienced this landscape in walks through the Catskills and created paintings including local rivers and streams.

Artists often lodged at Cozzens' Hotel, with its inspiring view of the deep gorge at West Point, at the Catskill House in the mountains, or at Trenton Falls House, which also attracted writers. John Frederick Kensett, Jasper Francis Cropsey, and DeWitt Clinton Boutelle were among the many who sketched the woods along the Hudson and Mohawk rivers. These sketches, along with notations indicating the colors of foliage, rocks, and light, inspired monumental landscape paintings comparable in size and design to historical paintings. Many scenes were as spacious as a distant vista, like those at Hudson or West Point, while others were as intimate as the brooks at Warwick or the Catskills.

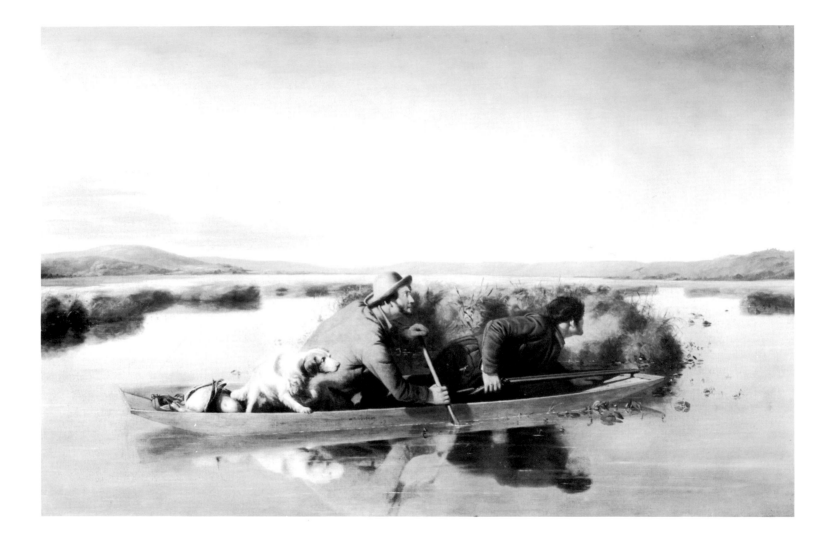

Hoboken Marshes William Tylee Ranney (1813–1857)
New Jersey *Duck Hunters on the Hoboken Marshes* 1849
oil on canvas; 26 x 40 in.
Museum of Fine Arts, Boston, Massachusetts
M. and M. Karolik Collection

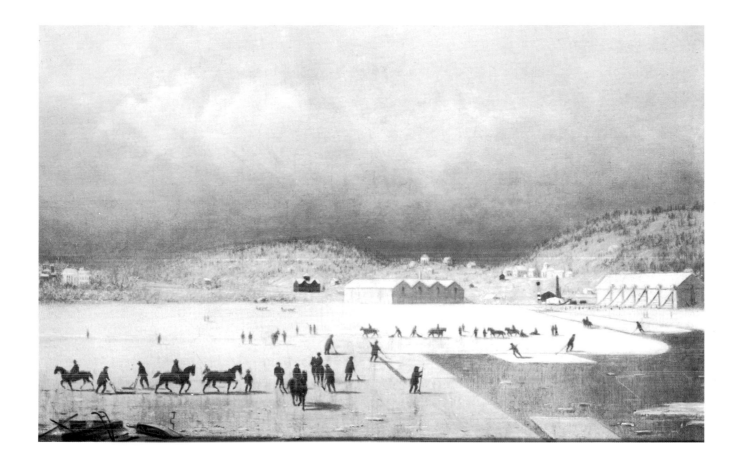

Rockland Lake Andrew Fisher Bunner (1841–1897)
New York *Cutting Ice, Rockland Lake, New York* ca. 1890
oil on canvas; 9⅛ x 14 in.
The New-York Historical Society, New York, New York

13

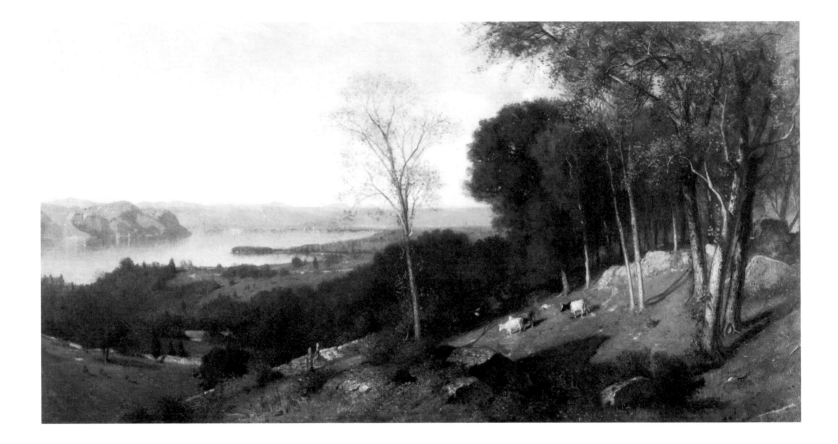

Hudson River Samuel Colman (1832–1920)
New York *Looking North from Ossining, New York* 1867
oil on canvas; 16⅜ x 30¼ in.
The Hudson River Museum, Yonkers, New York
Gift of the Estate of Miss Sarah Williams, 1944

Brook David Johnson (1827–1908)
New York *Brook Study at Warwick* 1873
oil on canvas; 25⅞ x 39⅞ in.
Munson-Williams-Proctor Institute, Utica, New York

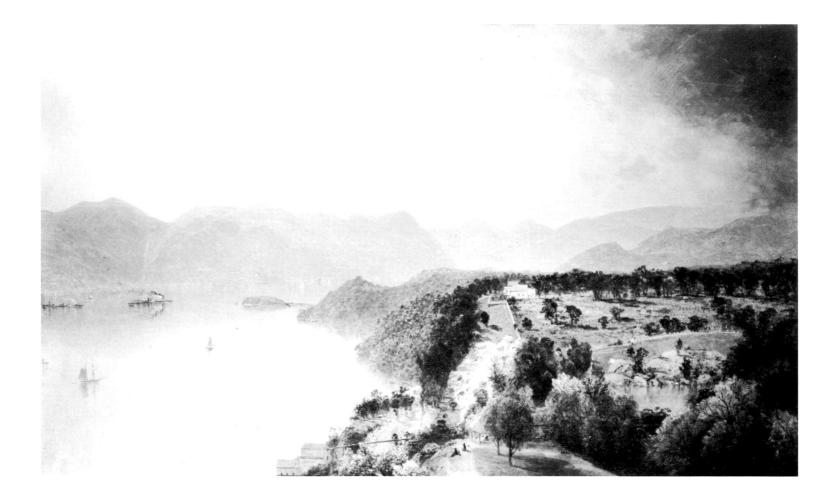

Hudson River John Frederick Kensett (1816–1872)
New York *View from Cozzens' Hotel Near West Point* 1863
oil on canvas; 20 x 34 in.

The New-York Historical Society, New York, New York

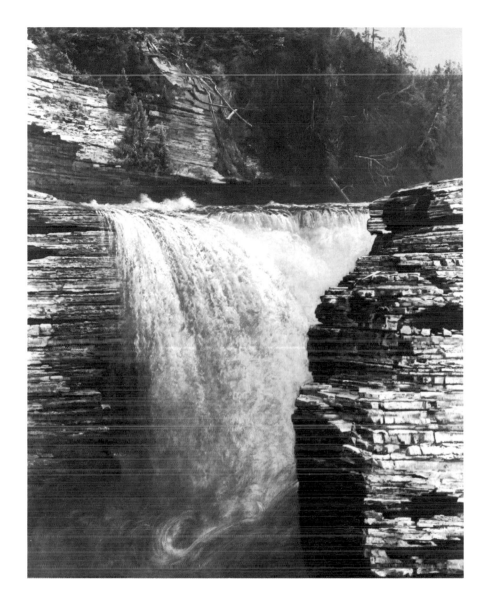

Trenton Falls DeWitt Clinton Boutelle (1820–1884)
New York *Trenton Falls, near Utica, New York* 1876
oil on canvas; 50½ x 40 in.
The Corcoran Gallery of Art, Washington, D.C.
Museum Purchase through a gift of S. H. Kauffmann, F. B. McGuire,
E. F. Andrews, John W. McCartney, Stilson Hutchins, and V. G. Fischer, 1979

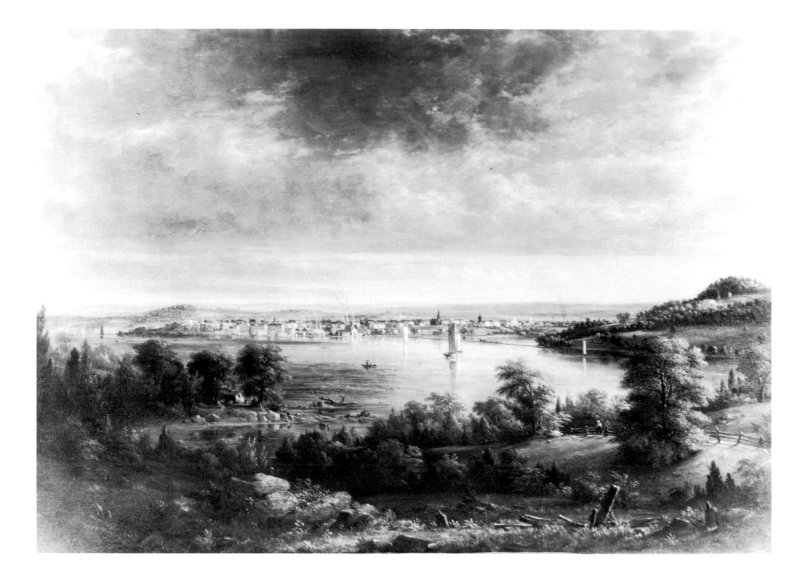

Hudson River Henry Ary (1807/08–1859)
New York *View of Hudson, New York* 1852
 oil on canvas; 26 x 36 in.
 Albany Institute of History and Art, Albany, New York

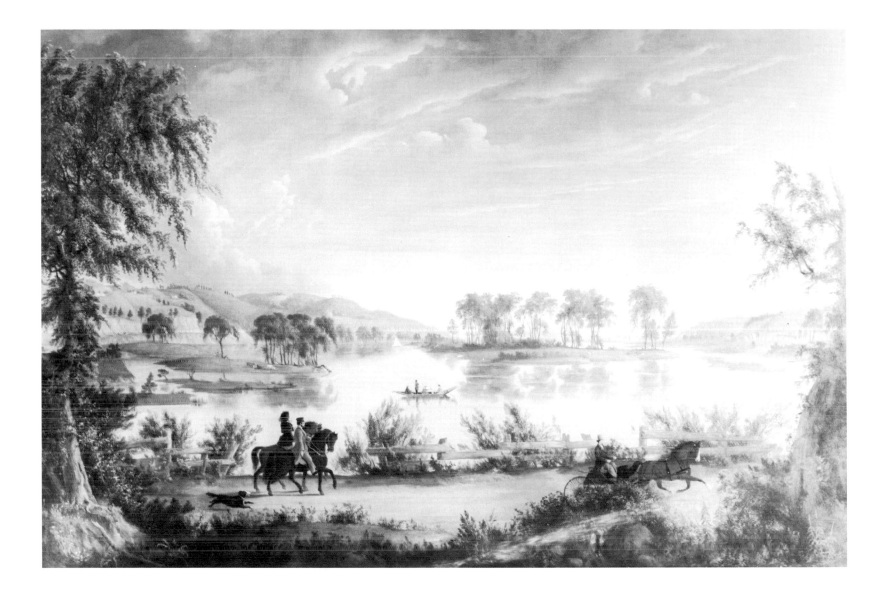

Hudson River Anonymous (19th century)
New York *Hillhouse Island near Troy, New York* undated
oil on canvas; 36⅜ x 54 in.
Albany Institute of History and Art, Albany, New York

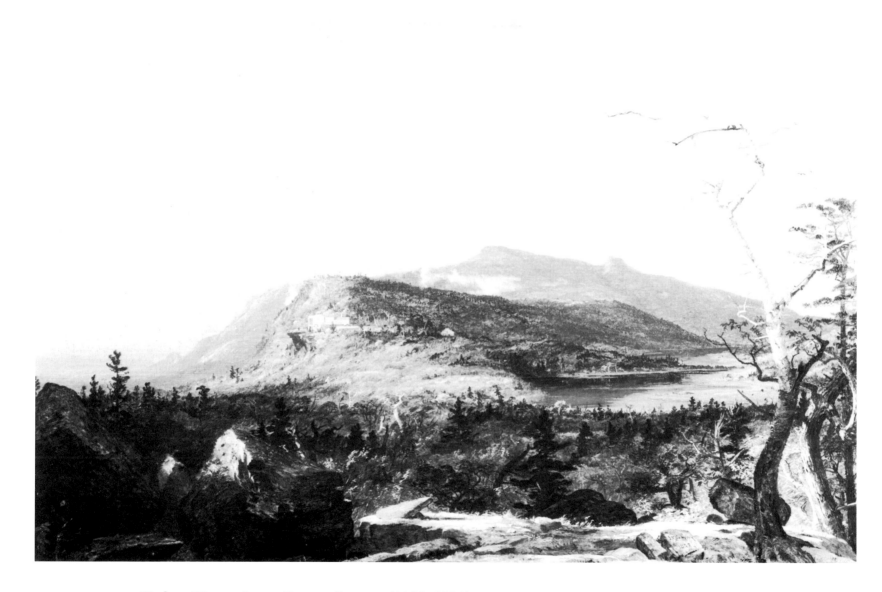

Hudson River Jasper Francis Cropsey (1823–1900)
 New York *View of the Catskill Mountain House* 1855
 oil on canvas; 29 x 44 in.
 The Minneapolis Institute of Arts, Minneapolis, Minnesota
 Bequest of Mrs. Lillian Lawhead Rinderer in memory of her brother,
 William A. Lawhead, and The William Hood Dunwoody Fund

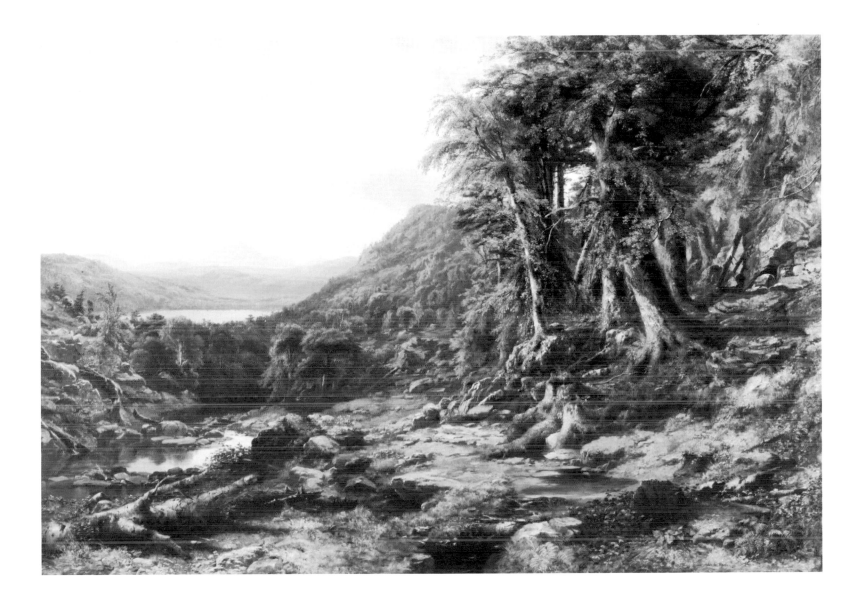

Catskill Creek James MacDougal Hart (1828–1901)
New York *Catskill Creek, New York* 1855
oil on canvas; 15½ x 66½ in.
Albright-Knox Art Gallery, Buffalo, New York
Bequest of Mrs. Millard Fillmore, Buffalo, 1881

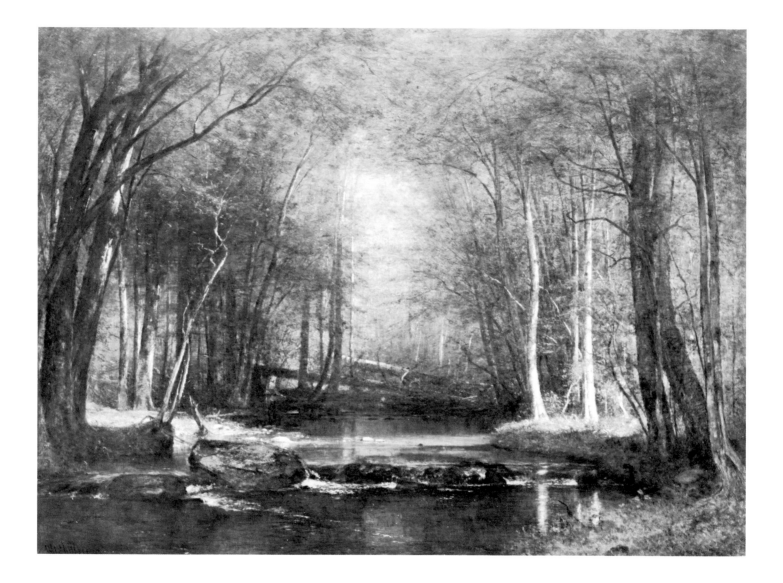

Trout Brook Thomas Worthington Whittredge (1820–1910)
New York *Trout Brook in the Catskills* 1875
 oil on canvas; 35½ x 48⅜ in.
 The Corcoran Gallery of Art, Washington, D.C.

Museum Purchase, 1875

Lake George, the Adirondacks, and New England

Beyond the Catskills lie the Adirondack Mountains, another segment of the Appalachian chain in upper New York State. Glacial action and surface erosion created their rugged topography—cutting mountains, shaping gorges, and filling lakes and streams. The mountains offered picturesque settings for hunting and skiing, as well as lakes for boating and sailing. Lakes George and Placid were particularly attractive sites for year-round resorts. Once the gathering place for the Iroquois Indian Confederation, Lake George was named in honor of England's King George, reigning monarch when the British defeated the French in a battle on the shores of the lake in 1755.

The beauty of the lake's setting made it equally popular among America's landscape painters. Although their styles differed, their compositions were similar: a wooded lakeshore in the foreground, balanced by mountains in the distance, the lake a mirror between them. Thomas Doughty, an outdoorsman who is acknowledged as the first American to specialize in landscape painting, worked these elements of the setting into compositions of studied nature, as did his contemporary Thomas Cole.

After the Civil War, later generations of artists painted the calm surface of the lake as reflective not only of the surrounding terrain, but also of the light and air. They viewed it from numerous vantage points in the mountains, at every time of day, and during every season of the year. Jasper Francis Cropsey preferred autumnal colors, so he painted Lake George in the fall. Alfred T. Bricher and Horace Walcott Robbins, on the other hand, visited the lake in spring or summer, judging from the light, color, and foliage present in their paintings.

The ranges of the Adirondack, Green, and White Mountains, where American artists sketched and painted the landscape in open air, separated New England from the west and made it the most unified American area with its puritan history and culture. The coastal harbors of Boston, Portland, and Salem supported shipping and fishing; inland towns were laid out along the rivers. Rocky hillsides hemmed in the farms, keeping them small and within the confines of the fertile river valleys.

Artists depicted these picturesque towns and their mills along the rivers, as well as recreational activities on the streams. Many of George Henry Durrie's intimate, sentimental landscapes of New England, for example, became popular with the American public through the prints of the New York company of Currier & Ives.

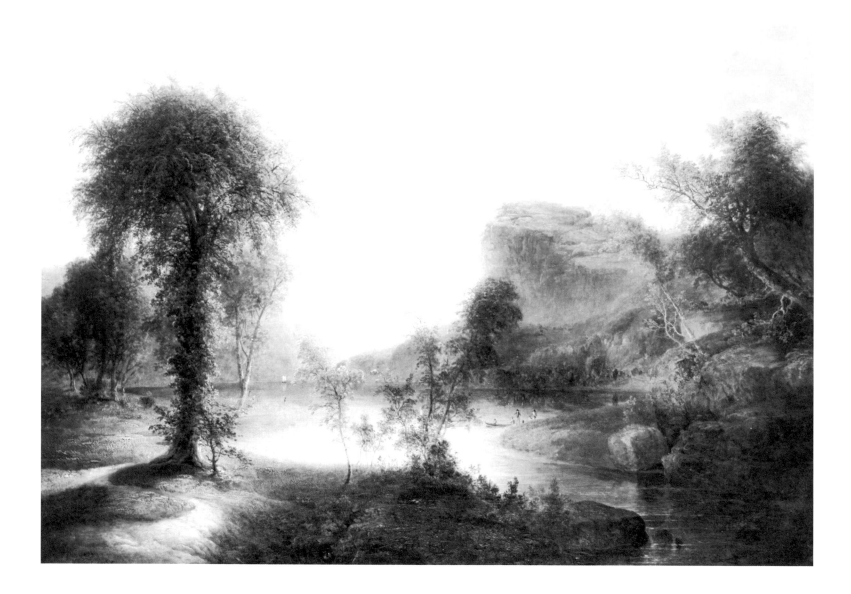

Lake George Thomas Doughty (1793–1856)
New York *Anthony's Nose, Lake George, New York* 1837–38
oil on canvas; 30⅛ x 42⅛ in.
Memphis Brooks Museum of Art, Memphis, Tennessee
24 Memphis Park Commission Purchase 46.1

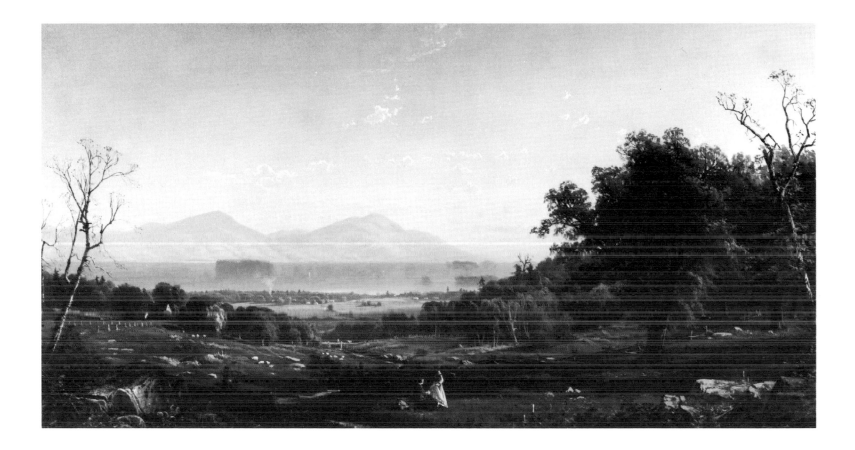

Lake George Alfred T. Bricher (1837–1908)
New York *Lake George from Bolton's Landing* 1867
oil on canvas; 27 x 50¼ in.
Daniel J. Terra Collection
Terra Museum of American Art, Evanston, Illinois

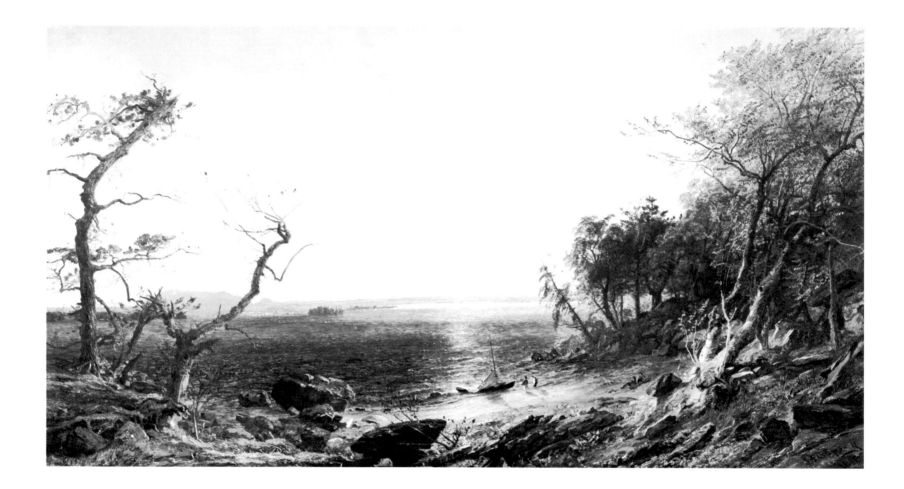

Lake George Jasper Francis Cropsey (1823–1900)
New York *Lake George* 1868
oil on canvas; 24 x 44 in.

IBM Corporation, Armonk, New York

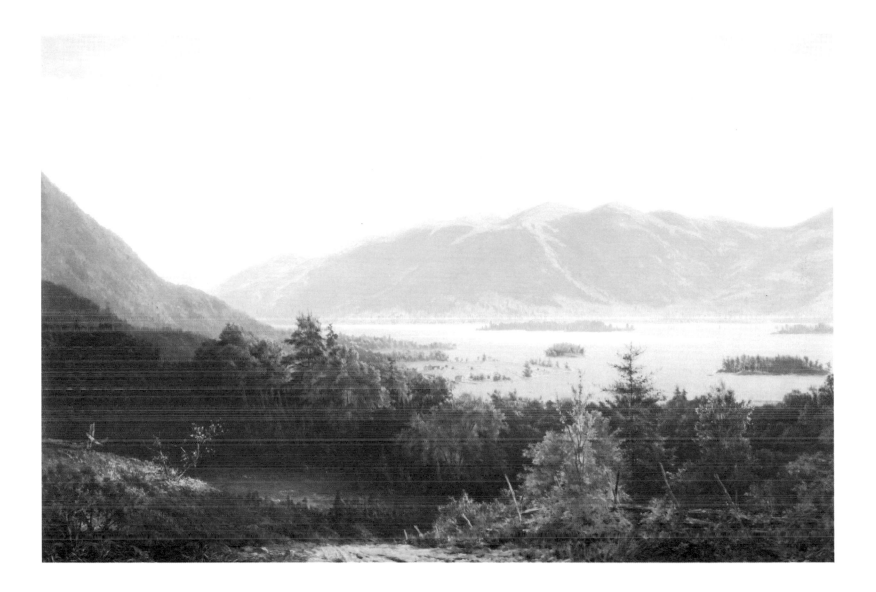

Lake George Horace Wolcott Robbins (1842–1904)
New York *Lake George* 1877
oil on canvas; 36¼ x 54⅜ in.
Ira Spanierman, Inc., New York, New York

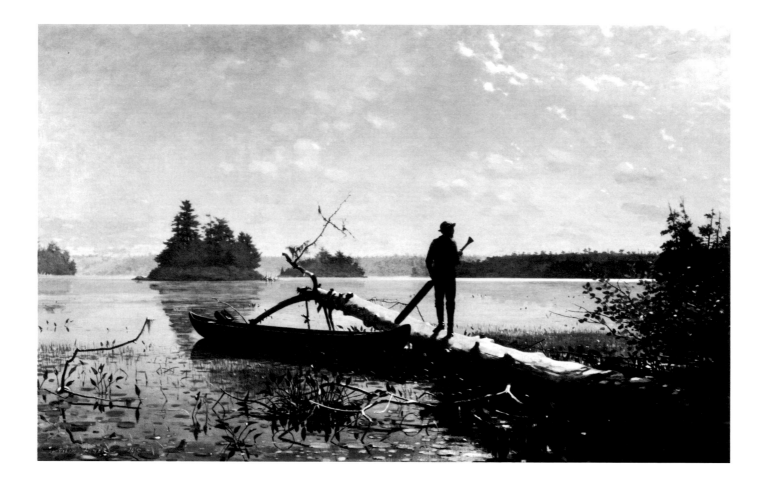

Lake Winslow Homer (1836–1910)
New York *An Adirondack Lake* 1870
 oil on canvas; 24¼ x 38¼ in.
 Henry Art Gallery, University of Washington, Seattle, Washington
28 Horace C. Henry Collection

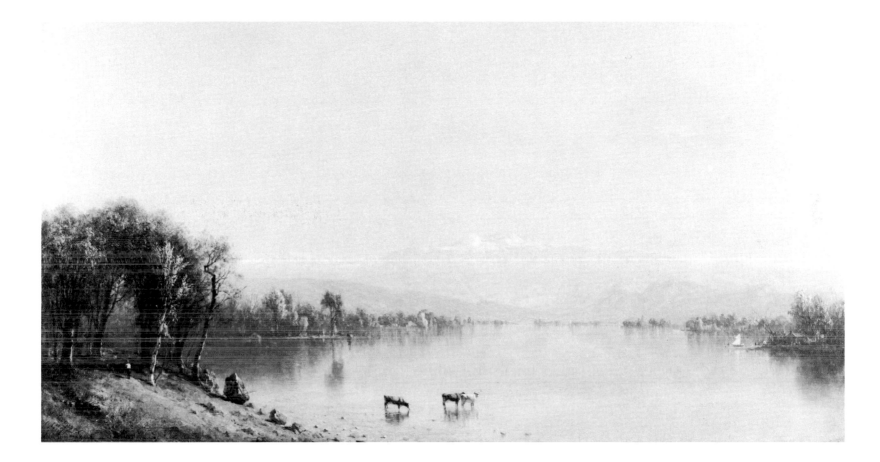

Lake Sebago Jasper Francis Cropsey (1823–1900)
Maine *Mt. Washington from Lake Sebago, Maine* 1871
oil on canvas; 16 x 30 in.
Mint Museum, Charlotte, North Carolina
Gift of Miss Elizabeth Boyd

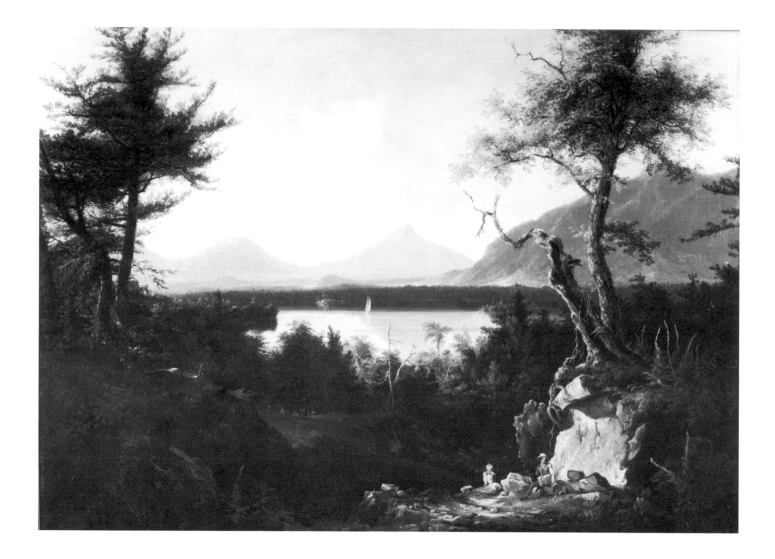

Lake Winnepesaukee Thomas Cole (1801–1848)
 New Hampshire *Lake Winnepesaukee* 1827 or 1828
 oil on canvas; 25½ x 35¼ in.
 Albany Institute of History and Art, Albany, New York
Gift of Mrs. Ledyard Cogswell, Jr.

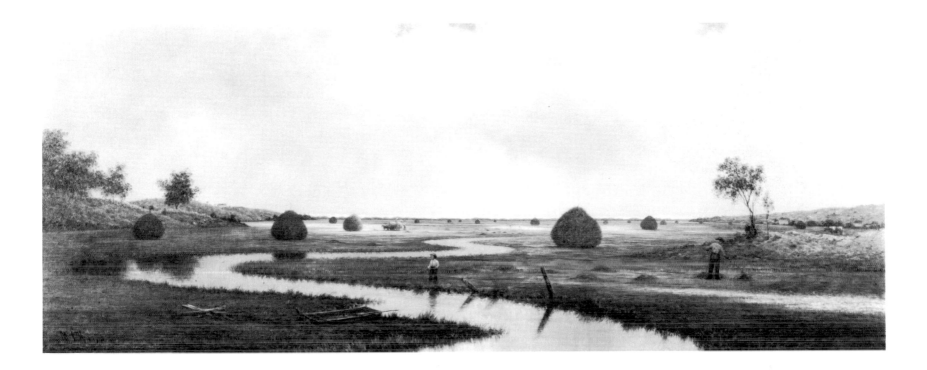

Marshes Martin Johnson Heade (1819–1904)
Rhode Island *Marshfield Meadow* 1878
oil on canvas; 17¾ x 44 in.
The Currier Gallery of Art, Manchester, New Hampshire

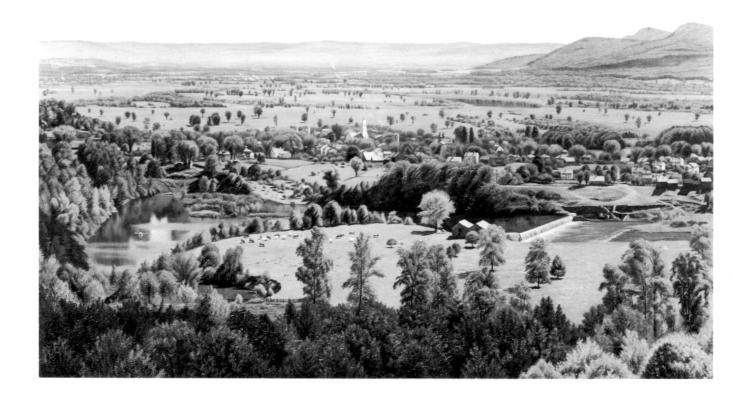

Connecticut River Thomas Charles Farrer (1839–1891)
Massachusetts *View of Northampton from the Dome of the Hospital* 1865
oil on canvas; 28⅛ x 36 in.
Smith College Museum of Art, Northampton, Massachusetts
Purchased 1953

32

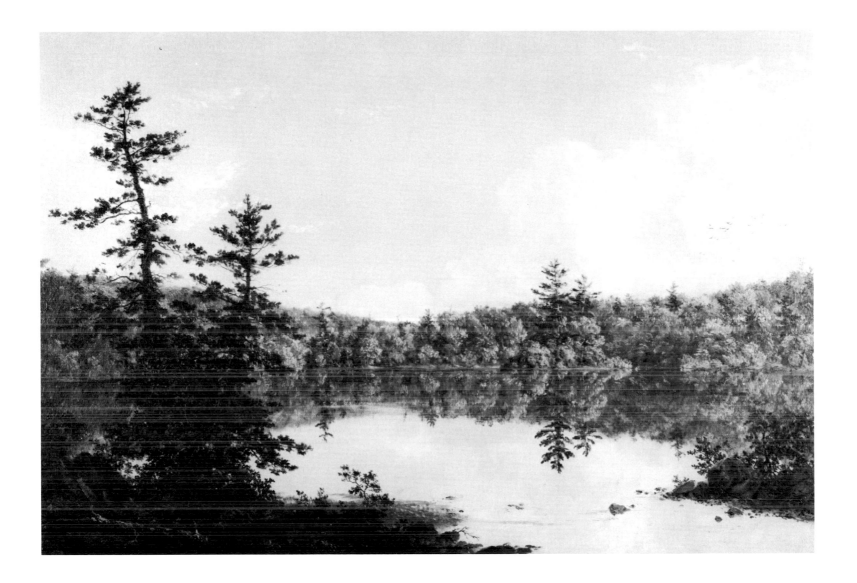

Stream Frederic Edwin Church (1826–1900)
Massachusetts *Autumn* ca. 1847
oil on canvas; 20 x 30½ in.
Heckscher Museum Collection, Huntington, New York
Gift of August Heckscher

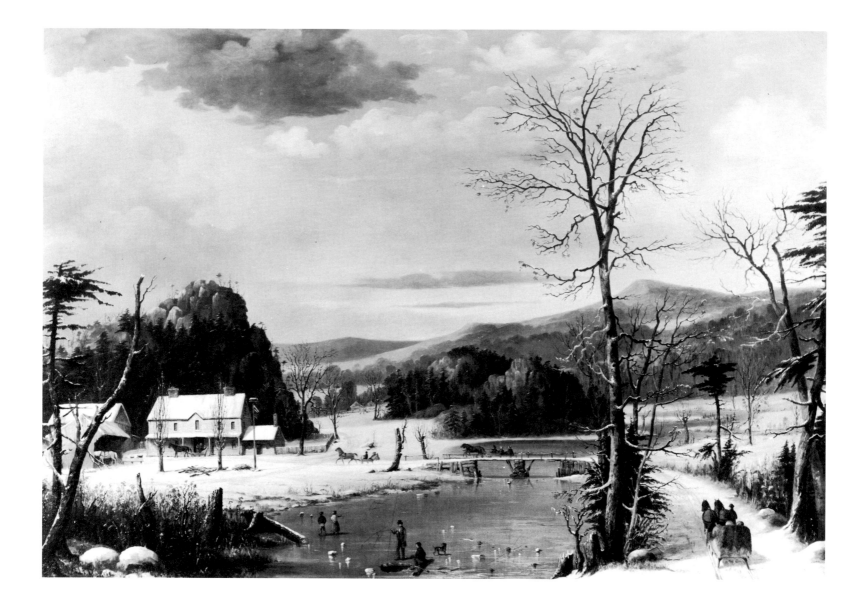

Pond George Henry Durrie (1820–1863)
New England *A Christmas Party* 1852
oil on canvas; 37 x 51 in.
The Thomas Gilcrease Institute of American History and Art, Tulsa, Oklahoma

34

Niagara Falls and the Great Lakes

Niagara Falls was one of the nation's first natural wonders. It inspired writers to describe its majesty and power and artists to portray its natural splendor. The falls are on the Niagara River, which carries water from Lake Erie to Lake Ontario. The river falls 164 feet over 28 miles and then dramatically plunges 162 feet at Horseshoe Falls. Above the falls, the river flows on a hard stone surface which resists erosion, until it reaches the falls where the riverbed becomes much softer. A steep step in the slope of the riverbed resulted, and Niagara Falls came into being.

The Great Lakes, the largest fresh-water lakes in the world, form one of the most important inland waterways in North America. Lake Michigan lies entirely within the United States, while the other four, Lakes Superior, Huron, Erie, and Ontario, form part of the boundary between the United States and Canada. They are interconnected by rivers and canals and are joined to the Atlantic Ocean by the St. Lawrence River.

Seventeenth-century French explorers traveled through all the Great Lakes, mapping a water route for the fur trade. Later, the French established trading posts at Chicago, Detroit, Buffalo, and Duluth. Discoveries of mineral deposits, like iron ore, coal, and oil, in the eighteenth and nineteenth centuries led to the formation of industrial centers on the lakes. The Erie Canal, which opened in 1825, linked Lake Erie with the Hudson River, thereby creating a water transportation system from the midwest to New York City. Buffalo became a flour-milling center; Detroit became a shipping and rail center and a port of entry; and Duluth was first a shipping center for timber and then for steel and grain.

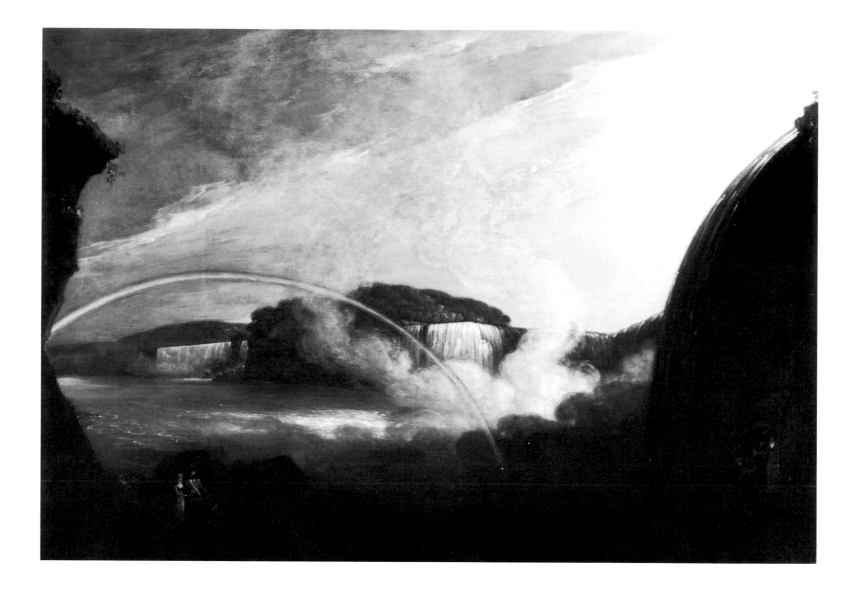

Niagara Falls John Trumbull (1756–1843)
Canada *Niagara Falls from below the Great Cascade on the British Side* ca. 1808
oil on canvas; 24⁷⁄₁₆ x 36³⁄₈ in.
Wadsworth Atheneum, Hartford, Connecticut
Bequest of Daniel Wadsworth

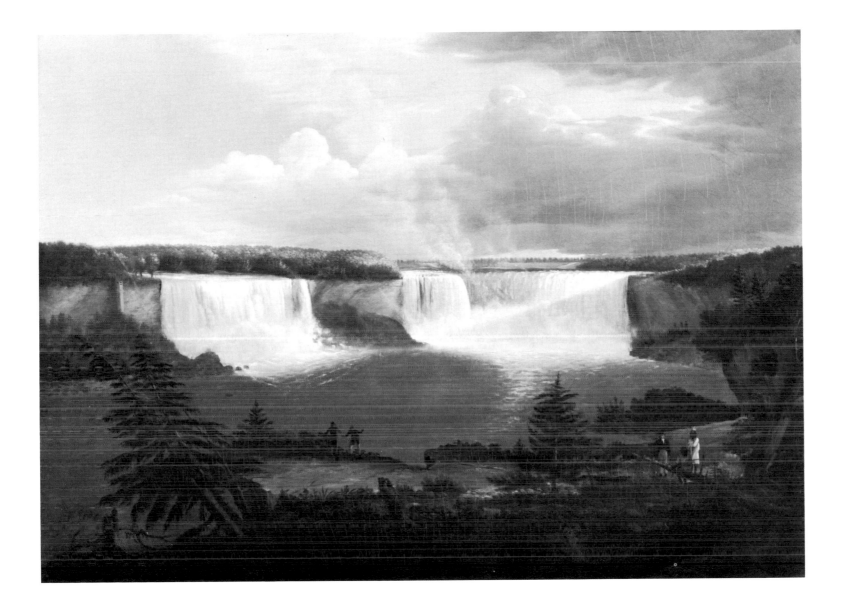

Niagara Falls Alvan Fisher (1792–1863)
New York *A General View of the Falls of Niagara* 1820
oil on canvas; 34⅜ x 48¼ in.
National Museum of American Art, Smithsonian Institution, Washington, D.C.

37

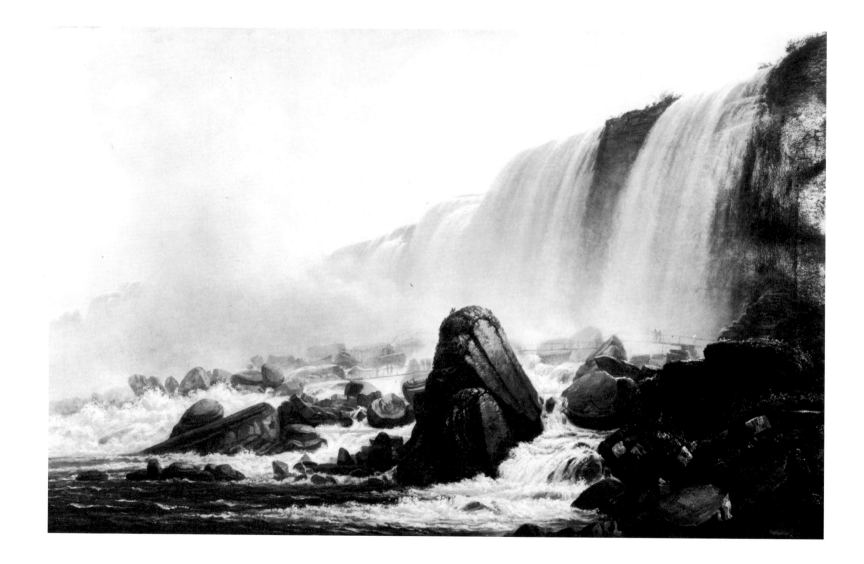

Niagara Falls Ferdinand J. Richardt (1819–1895)
Canada *Niagara Falls, Canadian Side* 1855
oil on canvas; 34 x 56 in.
Justina and Frank Keller, New Orleans, Louisiana

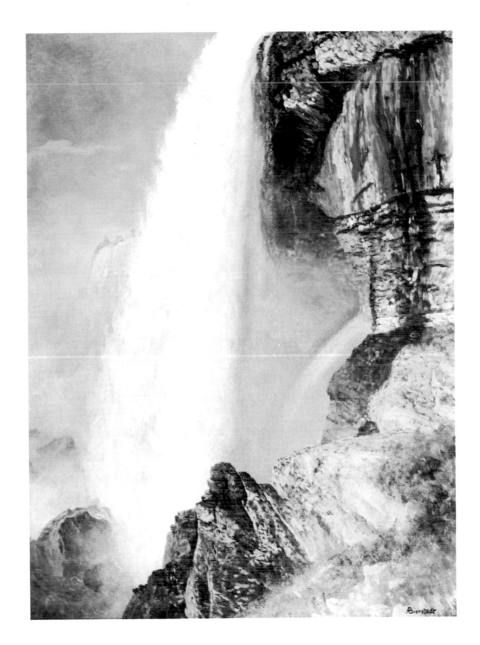

Niagara Falls Albert Bierstadt (1830–1902)
New York *Niagara Falls* ca. 1869–70
oil on canvas; 25 x 20 in.
The Thomas Gilcrease Institute of American History and Art, Tulsa, Oklahoma

39

Buffalo Harbor Lars Gustaf Sellstedt (1819–1911)
New York *Buffalo Harbor from the Foot of Porter Avenue* 1871
oil on canvas; 18 x 30 in.
Albright-Knox Art Gallery, Buffalo, New York
Gift of Henry A. Richmond, 1978

40

Detroit River Robert Hopkin (1832–1909)
Michigan *View of Belle Isle* 1871
oil on canvas; 32 x 55 in.
The Dossin Great Lakes Museum, Detroit, Michigan

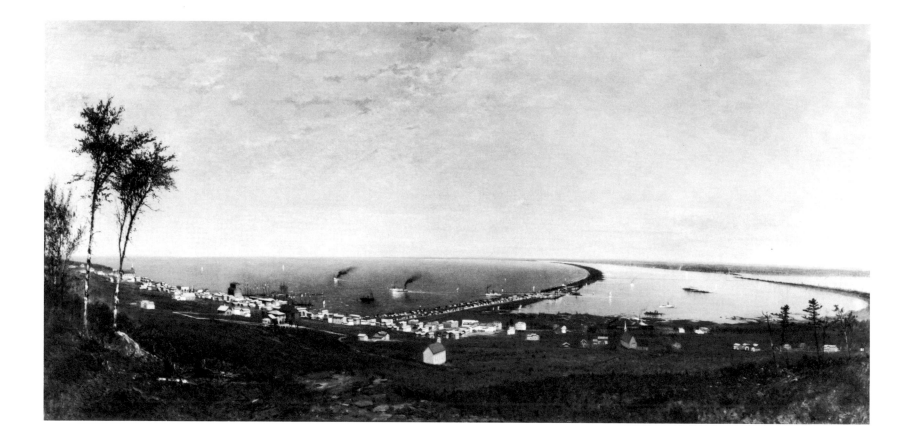

Lake Superior Gilbert Munger (1835–1903)
Minnesota *View of Duluth from the Heights* 1871
 oil on canvas; 25 x 50 in.
 Duluth Public Library, Duluth, Minnesota

Delaware, Susquehanna, and Ohio Rivers

Two major rivers in eastern Pennsylvania, the Delaware and Susquehanna, run north-south and terminate in large bays on the Atlantic Ocean. Settled by the Quakers, Pennsylvania became a haven for English and German religious dissenters whose industriousness turned the region into a prosperous dairy farmland.

Between its source in the Catskill Mountains and its outlet in Delaware Bay, the Delaware River marks the eastern boundary of Pennsylvania. Situated on the Delaware, Philadelphia became the center of the shipbuilding and chemical industries, and, in the eighteenth century, the largest city in the colonies and the center of government and culture.

The Pennsylvania Academy of Fine Arts in Philadelphia was the nation's leading art school for many years. Thomas Eakins, a faculty member, observed the local boating enthusiasts and painted them enjoying the water ways in sailboats and skulls along the Delaware and its tributary, the Schuylkill. George Inness, another prominent post-Civil War artist, viewed the Delaware Water Gap, the gorge carved by the Delaware through the Kittatinny mountains near Stroudsburg, Pennsylvania.

The Susquehanna River, the longest on the eastern seaboard, originates in Otsego Lake in New York, flows through New York and central Pennsylvania and empties into the Chesapeake Bay. Its swift current and many waterfalls, as well as abundant mineral deposits, encouraged manufacturing and farming.

The Ohio River, Pennsylvania's third major river, begins where the Allegheny and Monongahela Rivers meet at Pittsburgh, then flows southwestward along the southern border of Ohio State, emptying into the Mississippi River. The river's course provides a major link in the continuing water route west and south by connecting Pittsburgh with the Gulf of Mexico. Settlers crossed the Appalachian Mountains to Pittsburgh and then floated down the Ohio River to settlements along its banks or those of its tributaries, Beaver River near Pittsburgh and the Miami River near Cincinnati.

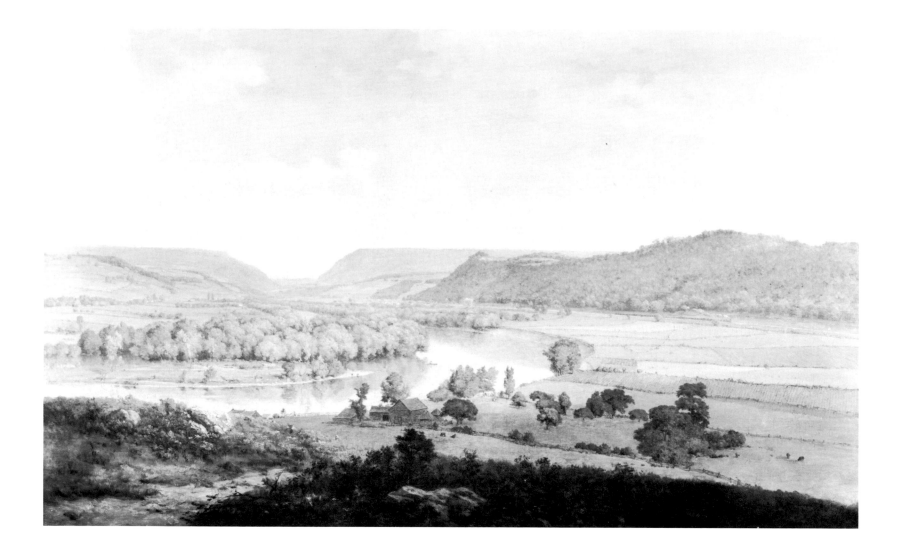

Delaware Water Gap George Inness (1825–1894)
Pennsylvania *Delaware Water Gap* 1859
 oil on canvas; 32 x 52 in.
 Montclair Art Museum, Montclair, New Jersey
44 Gift of Mrs. F. G. Herman Fayen

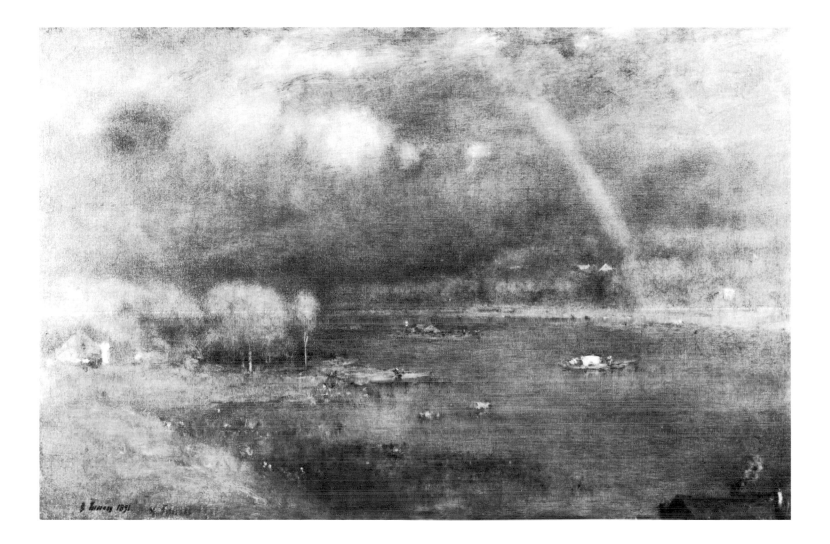

Delaware River George Inness (1825–1894)
Storm on the Delaware 1891
oil on canvas; 29¾ x 44¾ in.
Washington University Gallery of Art, St. Louis, Missouri
University Purchase, Bixby Fund, 1910

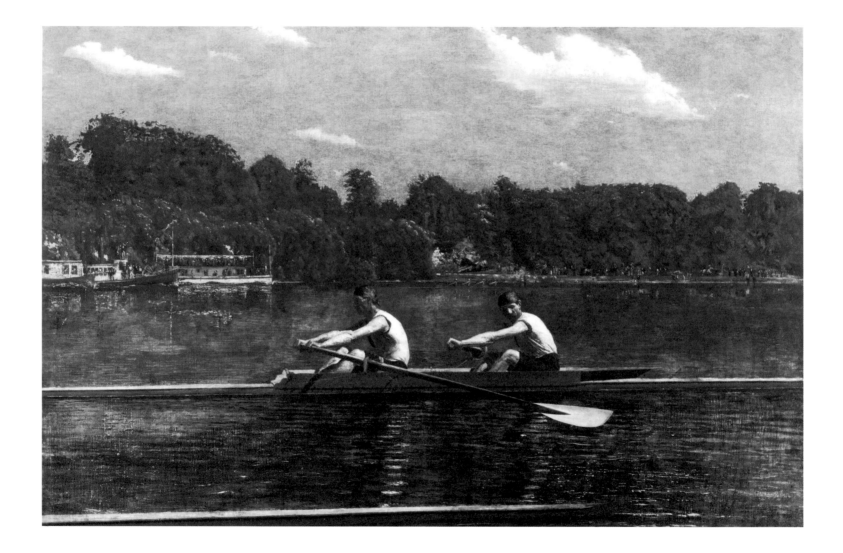

Schuylkill River Thomas Eakins (1844–1916)
Pennsylvania *The Biglin Brothers Racing* ca. 1873
oil on canvas; 24⅛ x 36⅛ in.
National Gallery of Art, Washington, D.C.
Gift of Mr. and Mrs. Cornelius Vanderbilt Whitney, 1953

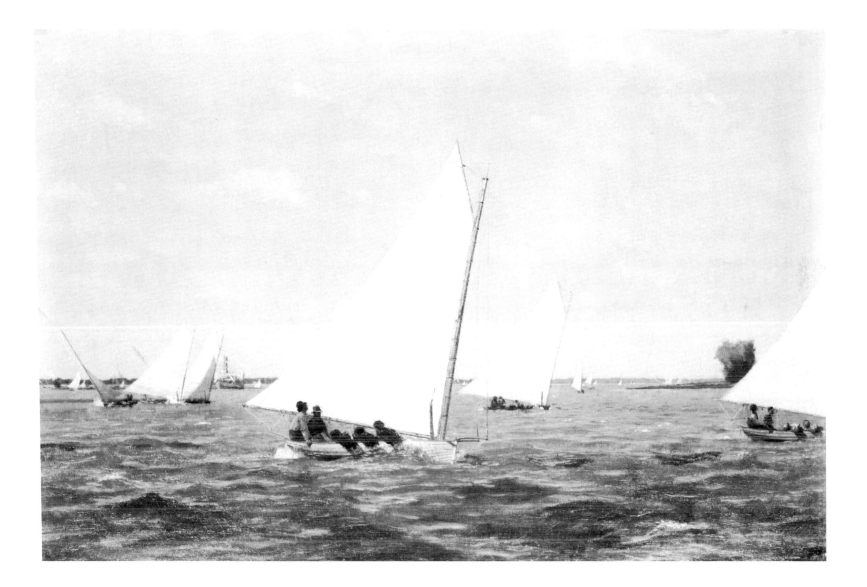

Delaware River Thomas Eakins (1844–1916)
 Sailboats Racing 1874
 oil on canvas; 24 x 36 in.
 Philadelphia Museum of Art, Philadelphia, Pennsylvania
 Gift of Mrs. Thomas Eakins and Miss Mary Adeline Williams

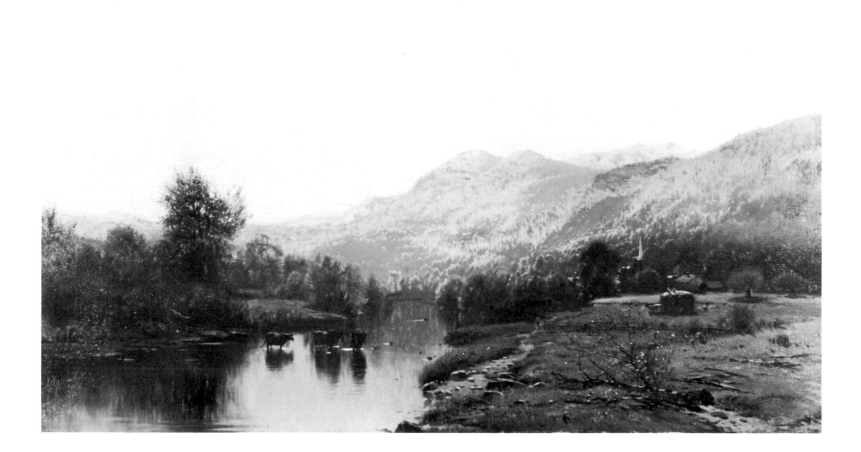

Delaware River John Frederick Kensett (1816–1872)
Scene on the Delaware 1856
oil on canvas; 28⅜ x 48¼ in.
Walker Art Center, Minneapolis, Minnesota
Gift of the T. B. Walker Foundation

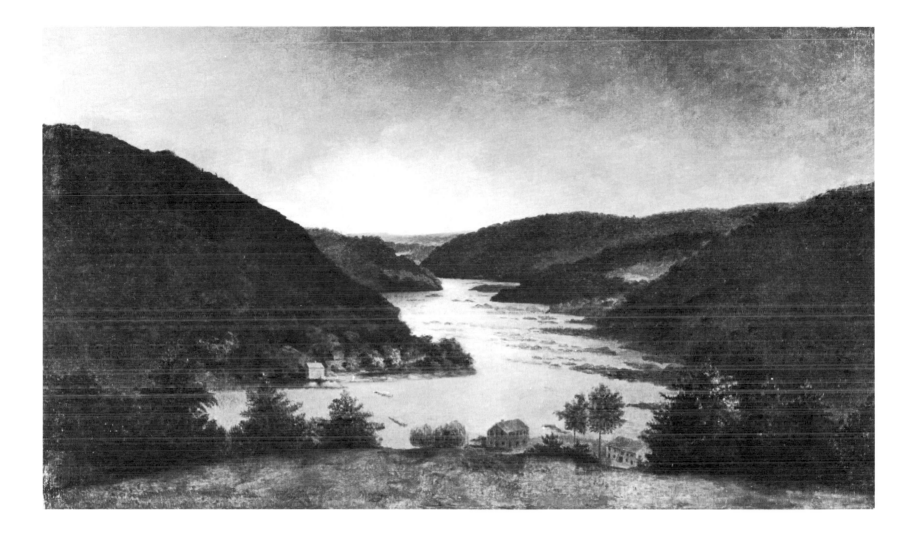

Potomac River Rembrandt Peale (1778–1860)
West Virginia *Harper's Ferry* undated
oil on canvas; 40¼ x 68 in.
Walker Art Center, Minneapolis, Minnesota
Gift of the T. B. Walker Foundation

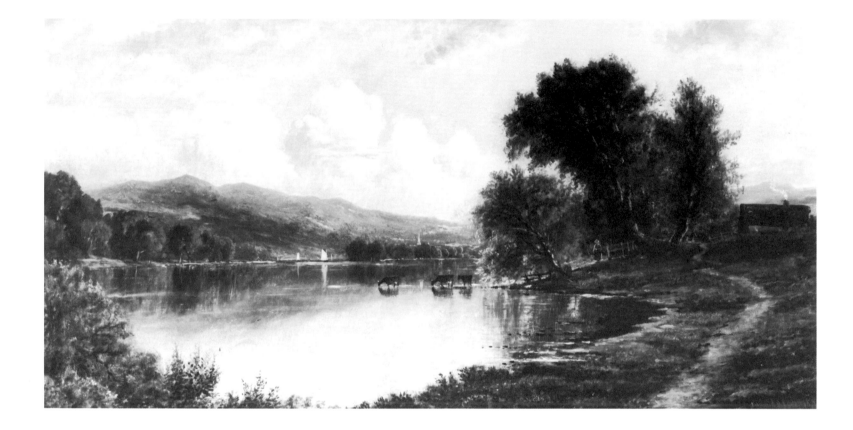

Susquehanna River Edmund Dartch Lewis (1835–1910)
Pennsylvania *On the Susquehanna* 1876
oil on canvas; 25 x 50½ in.

50 Diplomatic Reception Rooms, Department of State, Washington, D.C.

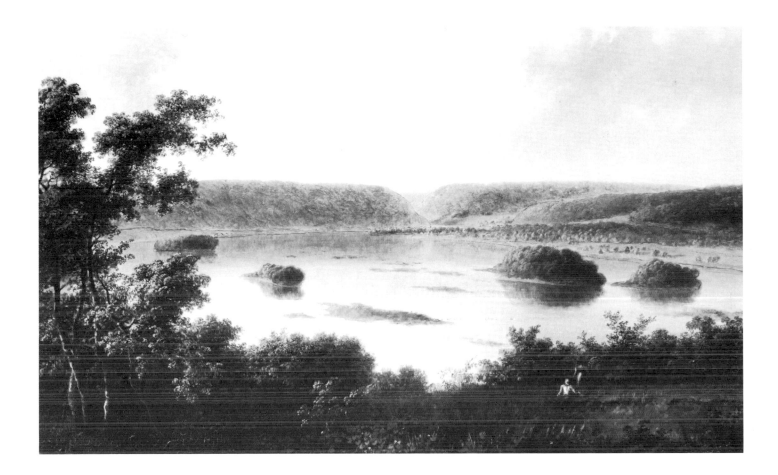

Susquehanna River Thomas Doughty (1793–1856)
Pennsylvania *On the Susquehanna near Harrisburg* ca. 1828–30
oil on canvas; 18¾ x 27½ in.
The Pennsylvania Academy of the Fine Arts, Philadelphia, Pennsylvania

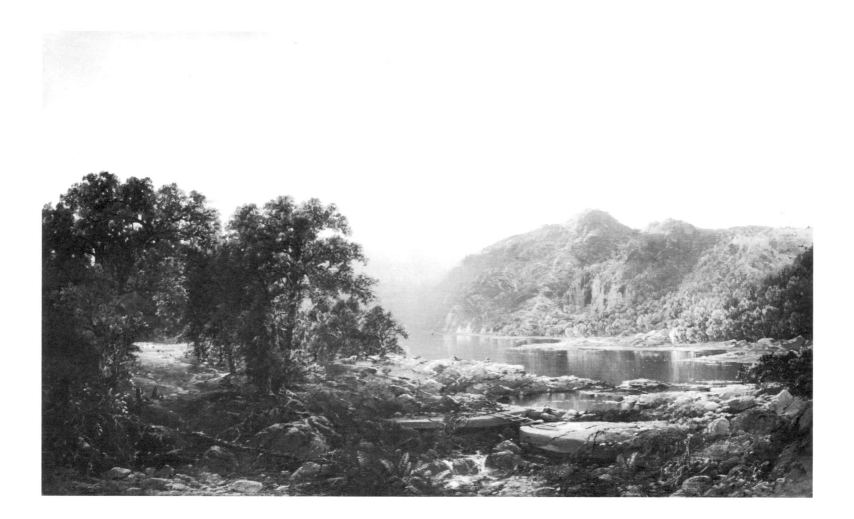

Susquehanna River
Pennsylvania

William Louis Sonntag (1822–1900)
The Susquehanna River near Bald Eagle Mountain 1864
oil on canvas; 30 x 50 in.
Museum of Art, Carnegie Institute, Pittsburgh, Pennsylvania
Gift of George L. Armour, New York, 1969

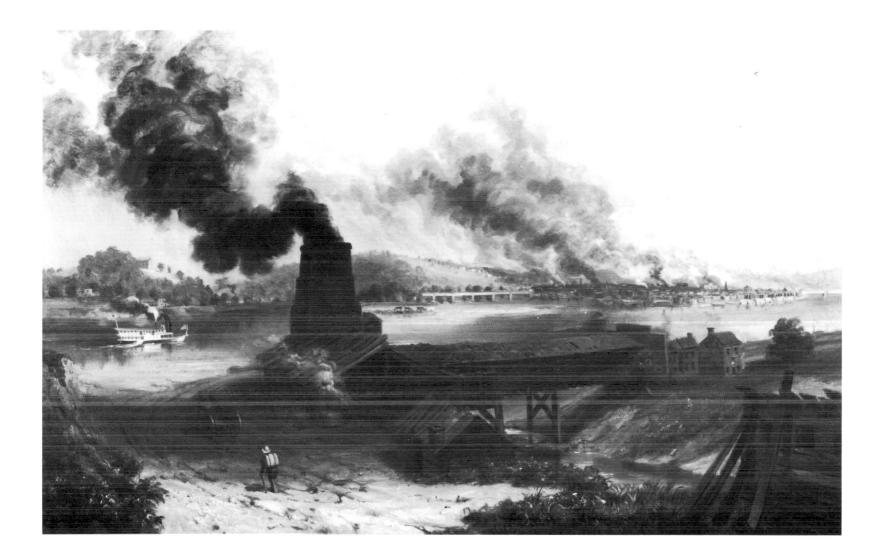

Allegheny, Ohio, and Russell Smith (1812–1896)
Monongahela Rivers *Pittsburgh Fifty Years Ago from the Salt Works on Sawmill*
Pennsylvania *Run* 1884
 oil on canvas; 22³⁄₁₆ x 36¹⁄₈ in.
 Museum of Art, Carnegie Institute, Pittsburgh, Pennsylvania
 Howard Heinz Endowment, 1977 53

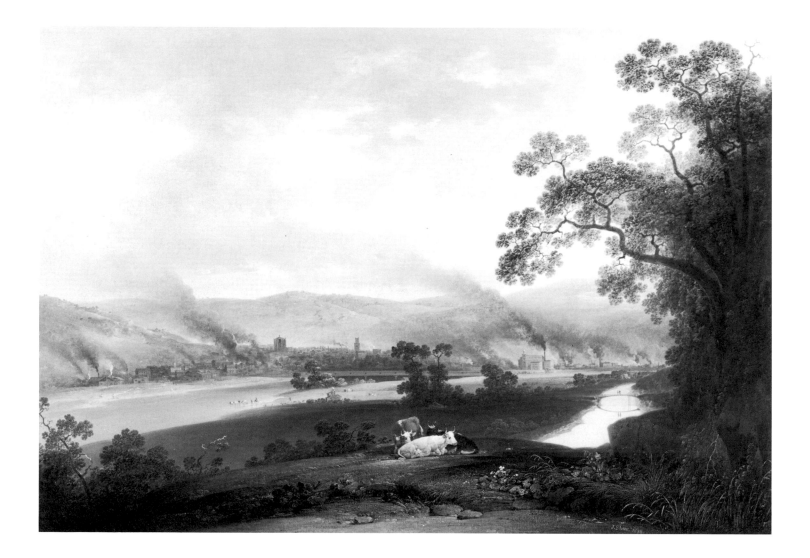

Kiskiminetas River Joshua Shaw (ca. 1777–1860)
Pennsylvania *View on the Kiskiminetas* 1838
oil on canvas; 32¾ x 48 in.
Diplomatic Reception Rooms, Department of State, Washington, D.C.

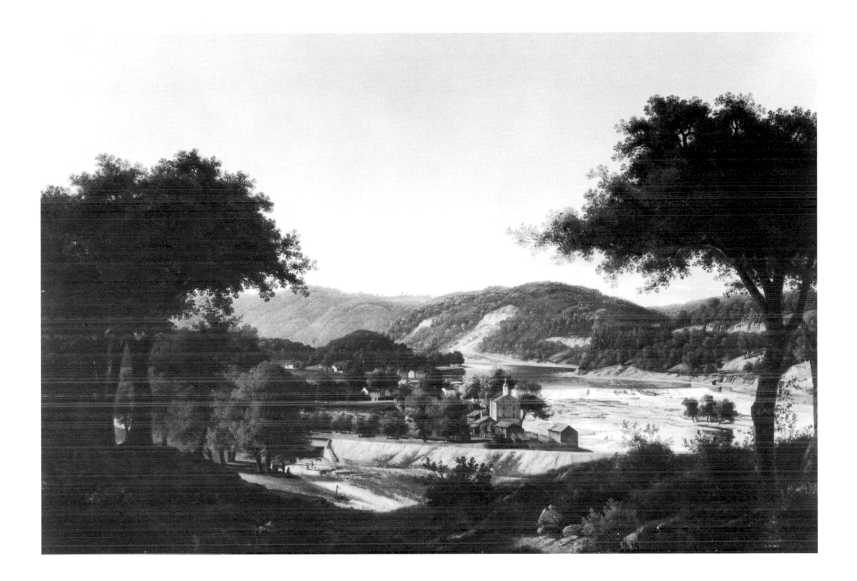

Beaver Falls Emil Bott (1827–1908)
Pennsylvania *Beaver Falls, Pennsylvania* 1854
oil on canvas; 25¼ x 38¼ in.
Westmoreland Museum of Art, Greensburg, Pennsylvania

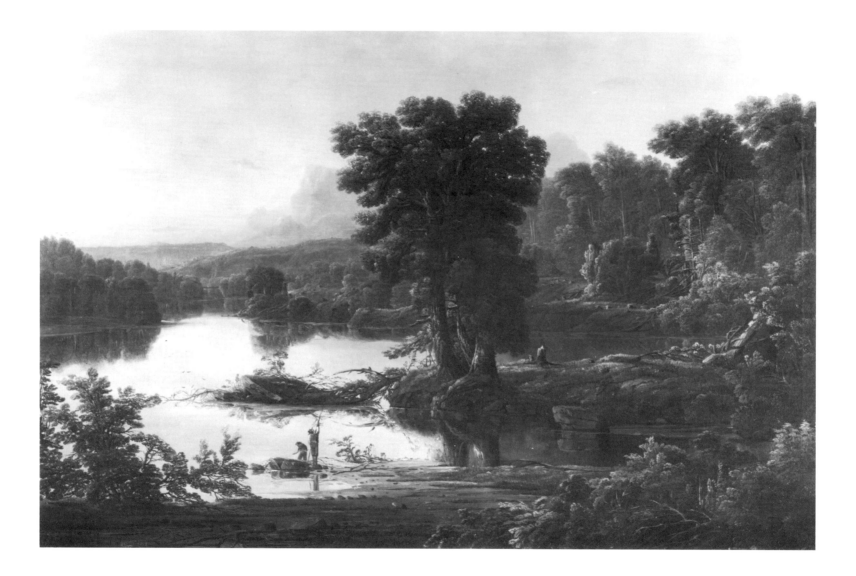

Little Miami River William Louis Sonntag (1822–1900)
Ohio *Scene on the Little Miami River* 1853
oil on canvas; 32 x 48¹⁄₁₆ in.
Cincinnati Art Museum, Cincinnati, Ohio
Gift of Mary Kilgour Miller, Edmond E. Miller, and Rufus King

Missouri and Mississippi Rivers

The Missouri River is formed by the confluence of the Jefferson, Madison, and Gallatin Rivers in western Montana. The longest river in the United States, it flows 2,714 miles across seven midwestern states to join the Mississippi River. The Mississippi River has its headwaters in Lake Itasca, Minnesota. It becomes navigable at St. Anthony Falls, in Minneapolis, and flows south 2,350 miles to empty into the Gulf of Mexico. The rivers together form a great drainage channel through the heartland of the United States.

Although the Spanish first reached the Mississippi, French explorers La Salle, Joliet, and Marquette opened the way for French settlement of the area. The French built a chain of fur trading posts and ports on both rivers, including St. Louis and New Orleans. Later, the area drained by the rivers came under the control of the Spanish, then the French once more, and, finally, by the Americans after the Louisiana Purchase. In 1804 Meriwether Lewis and William Clark ascended the Missouri from St. Louis in their exploration of America's newly acquired territory.

George Catlin became America's first important artist to travel through the new west. He left St. Louis in 1832 aboard the steamer *Yellowstone* and journeyed up the Missouri to North Dakota. He painted scenes of St. Louis and of the river bluffs on the upper Missouri. His series of paintings of Indians documented the western tribes for the curious American public; the American Indian seemed to be the only human element that could be appropriately introduced into the landscape without spoiling the purity of the western scenery.

The landscape along these rivers is quite different from that of the Hudson and other eastern rivers. The topography is flatter with only hills and bluffs overlooking the courses of the rivers. Where mountains stopped the eye in the distance of the Hudson River School paintings, here was only the infinite expansion of the view to a low horizon.

Not surprisingly the landscape of these rivers was the setting for paintings of men and their machines on the waterways. Because the Missouri and Mississippi rivers were highways for commerce, industry, and trade, paintings were not romantic observations on the beauty of the landscape, but instead featured steamboat captains and frontiersmen on flatboats. George Caleb Bingham and others portrayed these river characters who became American originals.

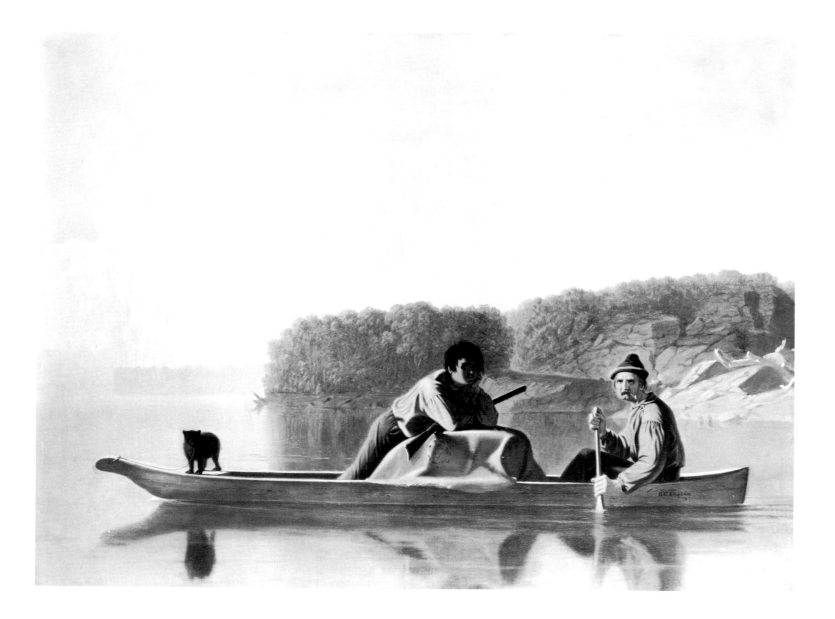

Missouri River George Caleb Bingham (1811–1879)
The Trappers' Return 1851
paint on canvas; 26¼ x 36¼ in.
The Detroit Institute of Arts, Detroit, Michigan
Gift of Dexter M. Ferry, Jr.

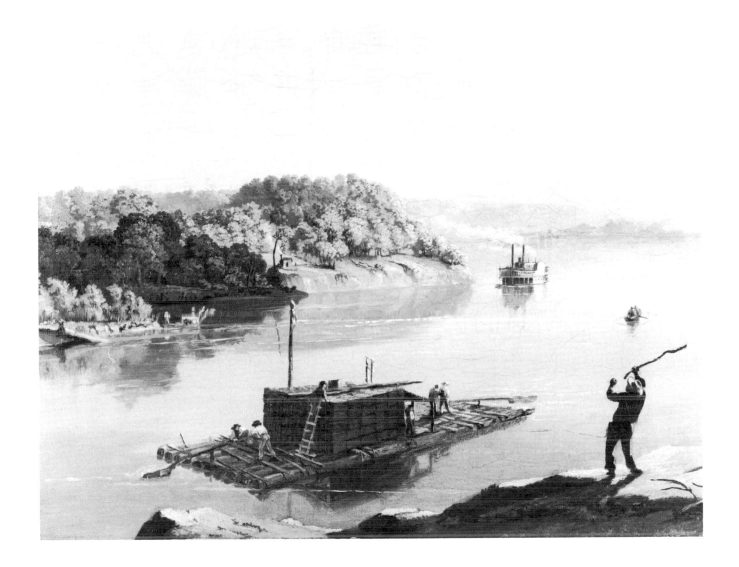

Mississippi or Anonymous (19th century)
Ohio River *Rafting Downstream* ca. 1840–50
oil on canvas; 18 x 23¾ in.
Indiana University Art Museum, Bloomington, Indiana

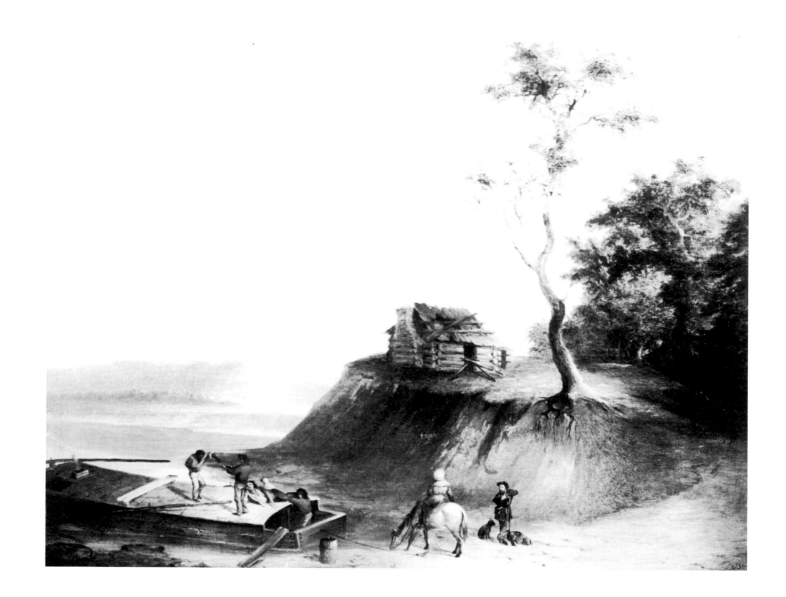

Mississippi or James Henry Beard (1812–1893)
Missouri River *Western Raftsmen* 1847
 oil on canvas; 29 x 36 in.
 Diplomatic Reception Rooms, Department of State, Washington, D.C.

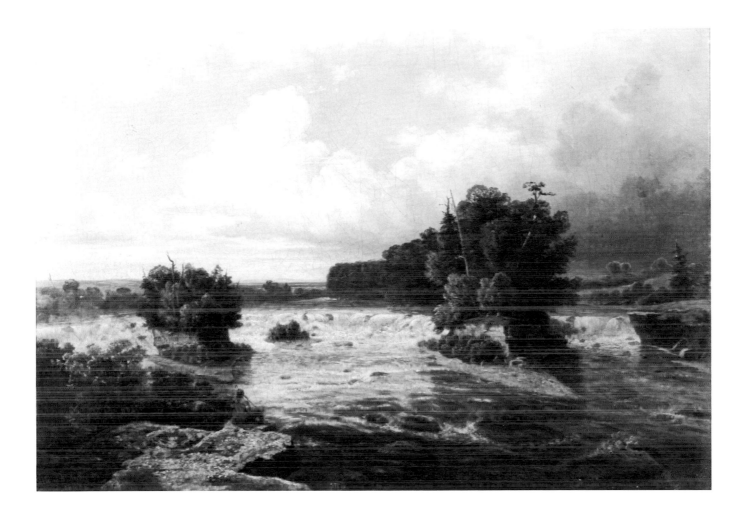

St. Anthony Falls Henry Lewis (1819–1904)
Minnesota *St. Anthony Falls As it Appeared in 1848* 1855
oil on canvas; 19 x 27 in.
The Minneapolis Institute of Arts, Minneapolis, Minnesota
Gift of Mr. E. C. Gale

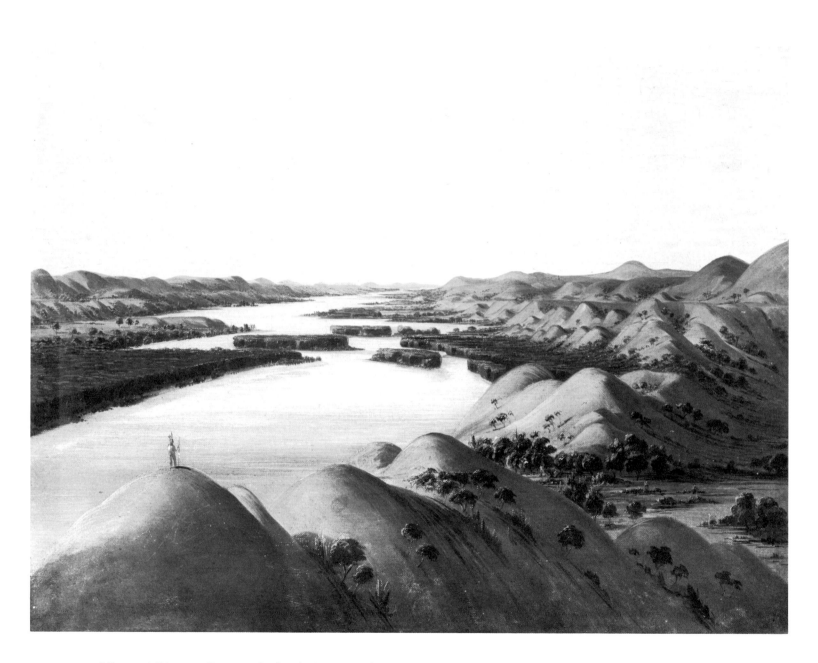

Missouri River George Catlin (1796–1872)
River Bluffs, 1320 Miles above St. Louis 1832
oil on canvas; 11¼ x 14½ in.
National Museum of American Art, Smithsonian Institution, Washington, D. C.
Gift of Mrs. Joseph Harrison, Jr.

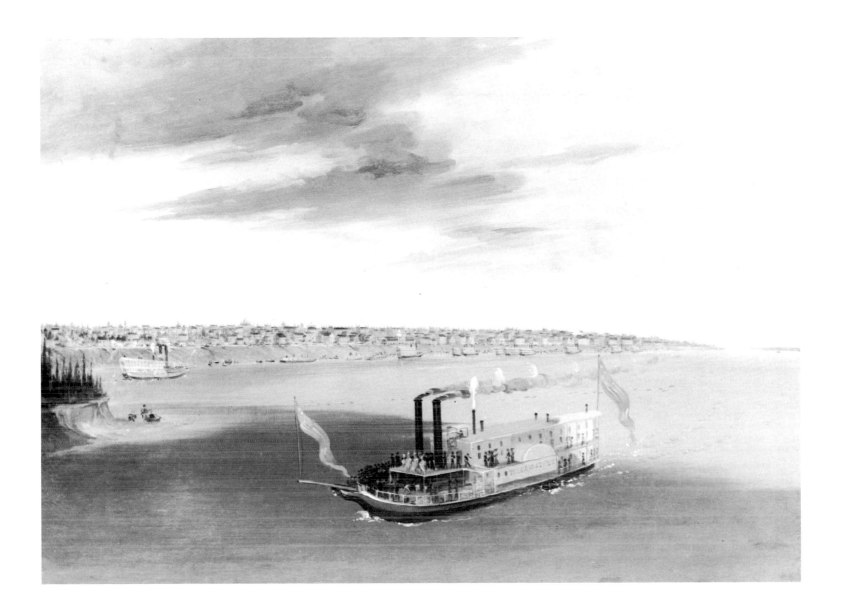

Mississippi River George Catlin (1796–1872)
Missouri *St. Louis from the River Below* 1832–33
oil on canvas; 19⅜ x 26⅞ in.
National Museum of American Art, Smithsonian Institution, Washington, D. C.
Gift of Mrs. Joseph Harrison, Jr.

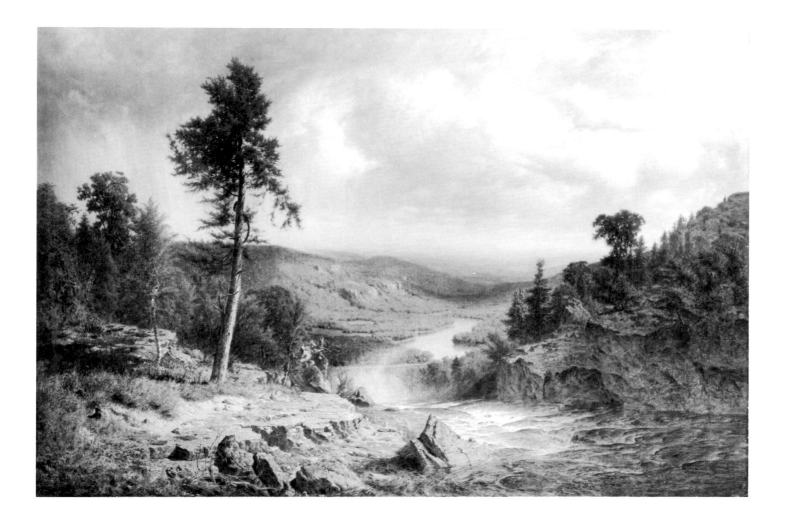

River Alexander Helwig Wyant (1836–1892)
Tennessee *Tennessee* 1866
 oil on canvas; 34¾ x 53¾ in.
 The Metropolitan Museum of Art, New York, New York
 Gift of Mrs. George E. Schanck,
 in memory of Arthur Hoppock Hearn 13.53

64

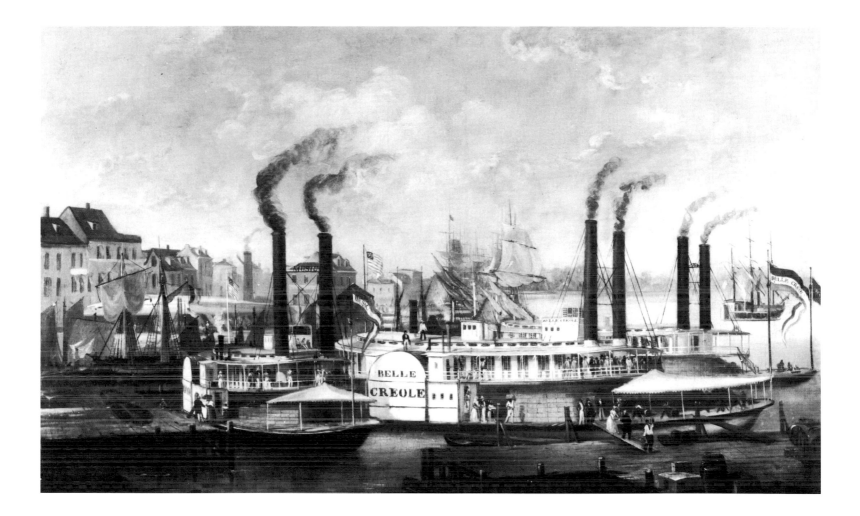

Mississippi River Anonymous (19th century)
Louisiana *The Belle Creole at New Orleans* ca. 1845–49
oil on canvas; 36⅛ x 56⅛ in.
The Corcoran Gallery of Art, Washington, D. C.
Gift from the Estate of Mrs. Emily Crane Chadbourne,
through her niece, Dr. Margaret C. L. Gildea, 1965

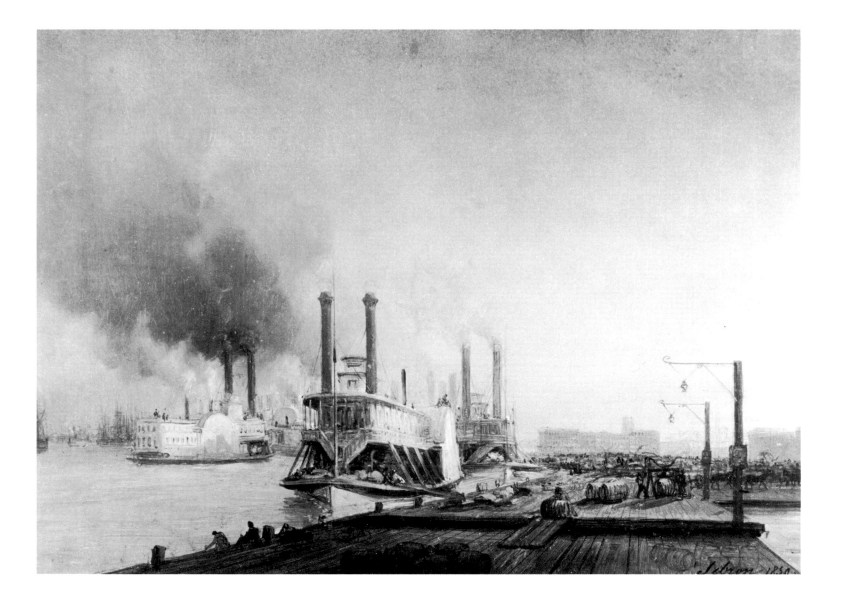

Mississippi River Hyppolite Victor Valentin Sebron (1801–1897)
Louisiana *Giant Steamboats at New Orleans* 1850
oil on canvas; 10¾ x 15⅜ in.
The Historic New Orleans Collection, New Orleans, Louisiana

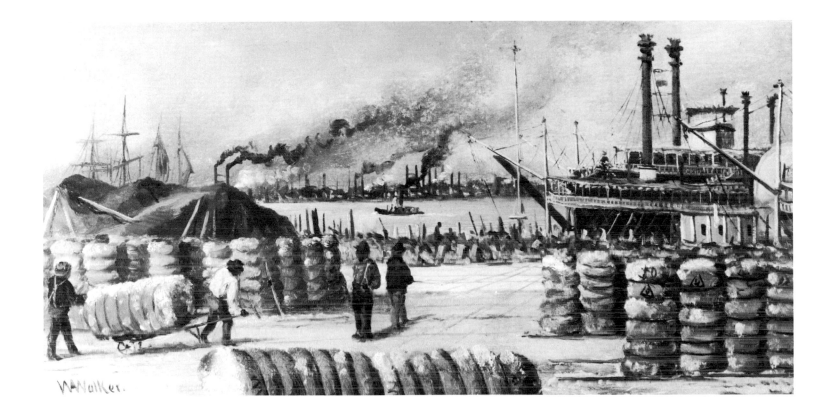

Mississippi River William Aiken Walker (1838–1921)
Louisiana *Loading Cotton, New Orleans* undated
oil on board; 6¼ x 12½ in.
The Historic New Orleans Collection, New Orleans, Louisiana

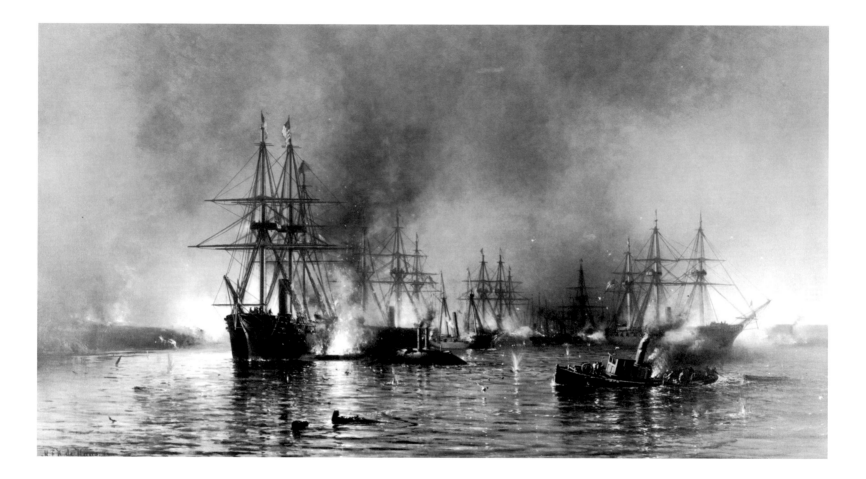

Mississippi River Mauritz Frederik Hendrik DeHaas (1832–1895)
Louisiana *Farragut's Fleet Passing the Forts Below New Orleans* ca. 1866
oil on canvas; 58½ x 105⅛ in.
The Historic New Orleans Collection, New Orleans, Louisiana

Louisiana Lakes, Bayous, and Swamps

The slow-moving bayous of Louisiana distribute the overflow from rivers, lakes, and swamps. The delta region, built up over thousands of years by river-carried silt, begins with the confluence of the Red River with the Mississippi in central Louisiana. Below this junction the land becomes lower, salt marshes appear, and bayous multiply. These Louisiana rivers and lakes are confined by levees, because much of the land lies below sea level.

The regions along the southwestern bayous were settled by the Acadians when they were expelled from Nova Scotia by the British after 1755. Bayous Teche and Lafourche, the principal bayous settled by the Acadians, flow through lush forests of cypress, oak, and magnolia, as well as fertile farmland. The Catholic, French-speaking Acadians built their simple cottages on the banks of the bayous; they farmed, fished, and continued the pastoral lifestyle of Nova Scotia. Some acquired large tracts of land, developed sugar and rice plantations, and built fine homes.

In the 1850s, while surveying for his famous map of the lower Mississippi River, Marie Adrien Persac traveled the rivers and bayous of Louisiana and painted "portraits" of many plantation homes. Joseph Rusling Meeker captured the atmosphere and scenic beauty of the Evangeline region in his somber landscapes.

Predating the Acadian immigration, the earliest plantations in Louisiana were built along Bayou St. John, which joined Lake Pontchartrain above New Orleans. The close proximity to Bayou St. John influenced the French to select the site for New Orleans. By water, travelers could reach the city and, by Bayou St. John, Lake Pontchartrain, and Lake Borgne, the Gulf of Mexico.

North of Lake Pontchartrain is a higher, pine-wooded region that became a vacation area for New Orleanians. Below New Orleans, water increases in proportion to land until they are virtually indistinguishable. These swamps, with their abundance and variety of fish and wildlife, have made fishing, trapping, and hunting important economic and recreational activites. Local artists Richard Clague, Marshall J. Smith, and William Henry Buck depicted the tranquility of the area in their paintings of fishing camps, vacation cottages, and swamps.

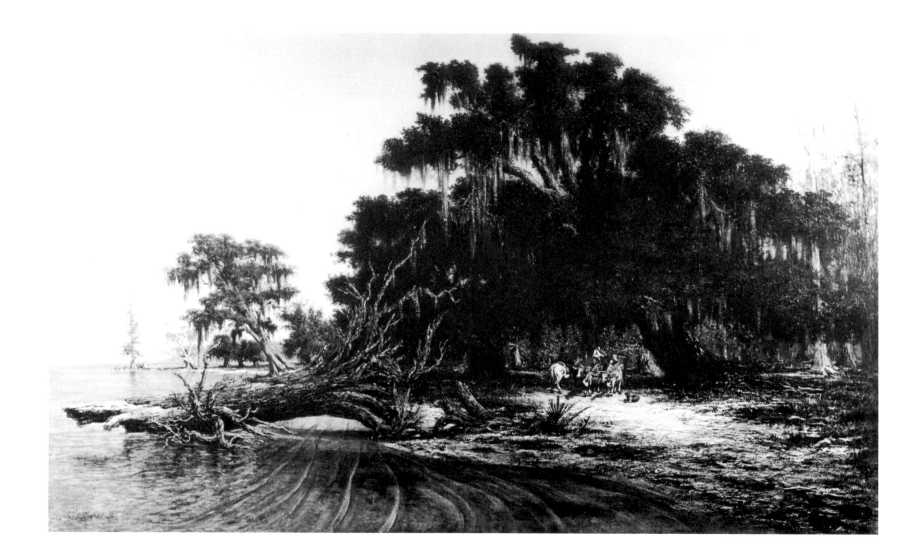

Lake Pontchartrain Richard Clague (1821–1873)
Louisiana *North Shore of Lake Pontchartrain at Mandeville* undated
oil on canvas; 36 x 60¼ in.

 Mr. Jay P. Altmayer, Mobile, Alabama

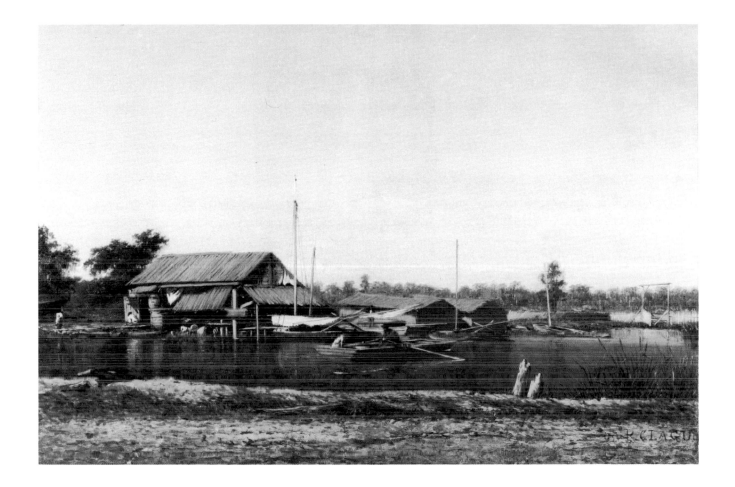

Bayou　Richard Clague (1821–1873)
Louisiana　*Fishing Camp on the Bayou*　ca. 1870
oil on canvas; 16 x 24½ in.
Mr. & Mrs. William E. Groves, New Orleans, Louisiana

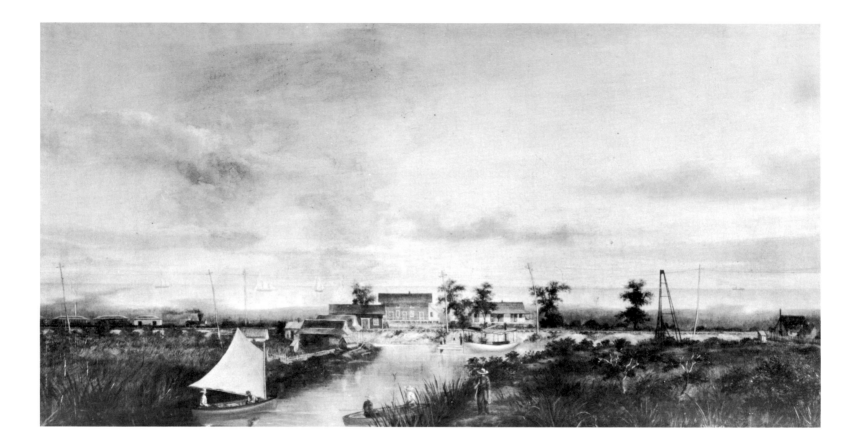

Lake Borgne William Henry Buck (1840–1888)
Louisiana *Fishing Camp on Lake Borgne* 1880
 oil on canvas; 15¾ x 30⅛ in.

72 The Historic New Orleans Collection, New Orleans, Louisiana

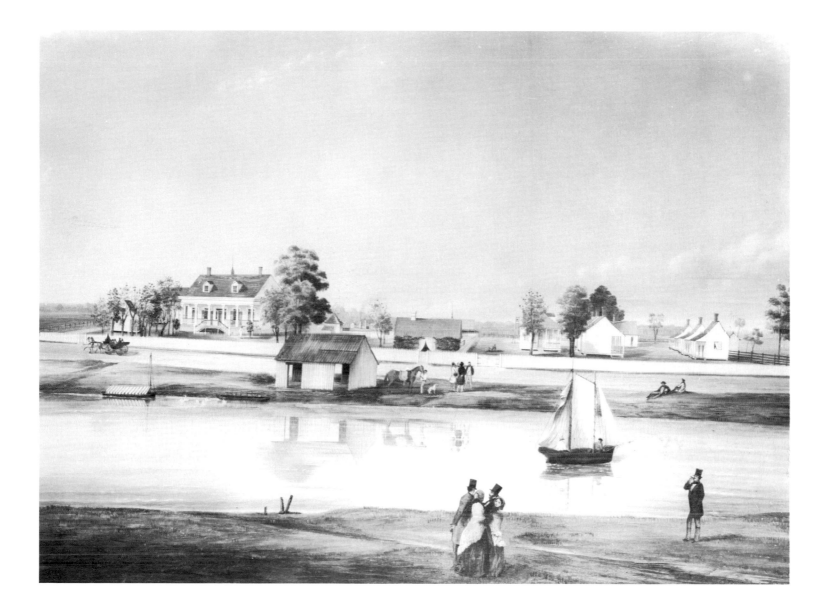

Bayou Lafourche Marie Adrien Persac (1823–1873)
Louisiana *Palo Alto Plantation* ca. 1855–60
gouache and collage on board; 18⅛ x 23½ in.
Mr. and Mrs. Arthur A. Lemann, Jr., Donaldsonville, Louisiana

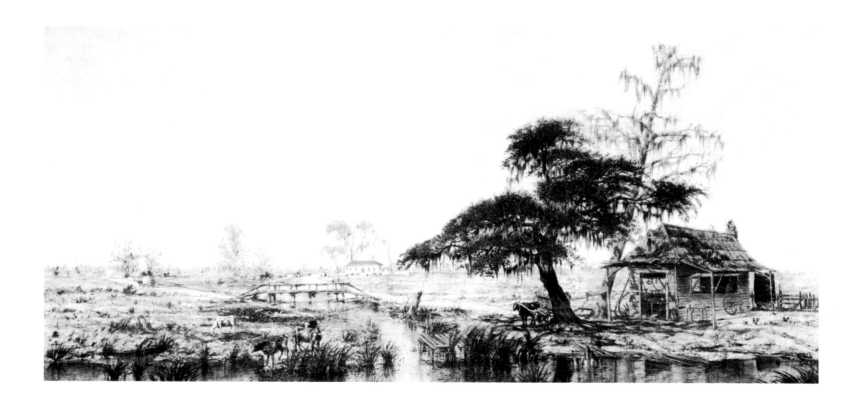

Bayou Marshall J. Smith (1854–1923)
Louisiana *Bayou Farm* undated
 oil on canvas; 17 x 36¼ in.
 New Orleans Museum of Art, New Orleans, Louisiana
 Gift of Mr. William E. Groves

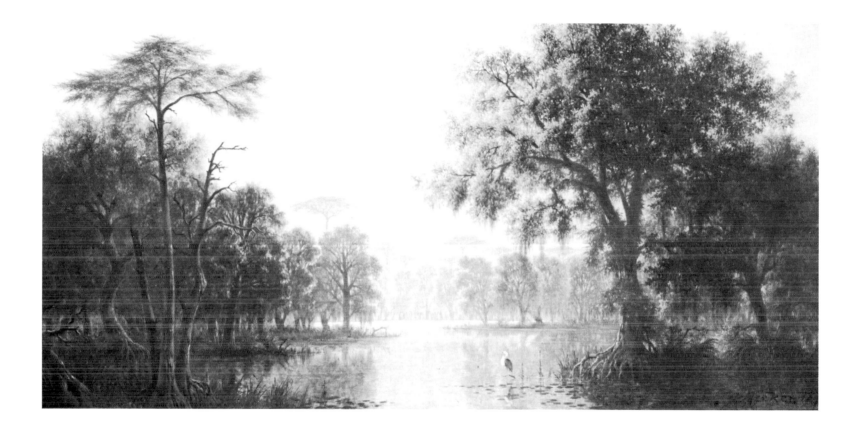

Bayou Joseph Rusling Meeker (1827–1889)
Louisiana *Bayou Landscape* 1872
 oil on canvas; 20 x 40 in.
 The Newark Museum, Newark, New Jersey 75

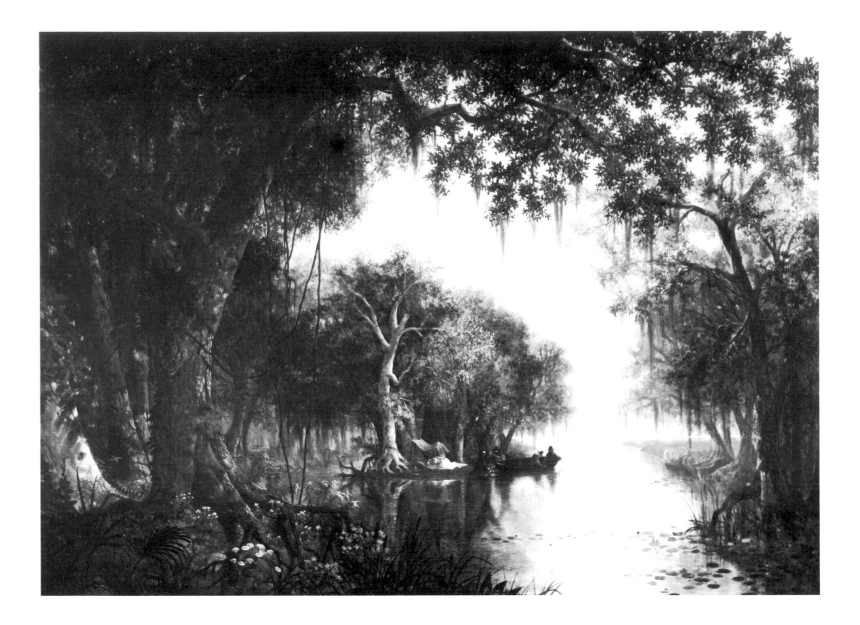

Bayou　Joseph Rusling Meeker (1827–1889)
Louisiana　*The Land of Evangeline*　1874
oil on canvas; 33 x 45½ in.
The Saint Louis Art Museum, St. Louis, Missouri
Gift of Mrs. W. P. Edgerton by exchange 163:1946

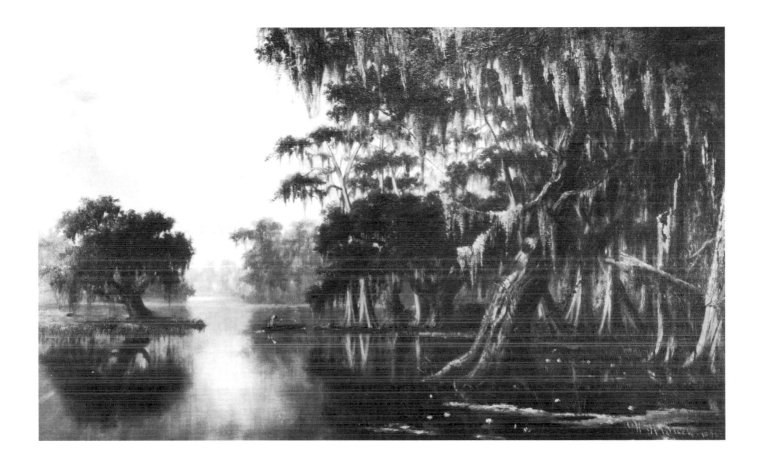

Swamp William Henry Buck (1840–1888)
Louisiana *Swamp Scene* 1887
oil on canvas; 16 x 28 in.
New Orleans Museum of Art, New Orleans, Louisiana
Gift of Miss Mary Bell Swanson Mayer

Bayou George David Coulon (1822–1904)
Louisiana *Bayou des Côtes, Parish of Avoyelles, Louisiana* 1891
 gouache on board; 12 x 16¼ in.
78 The Historic New Orleans Collection, New Orleans, Louisiana

The Northwest and Yellowstone

In the west, rivers, primarily the Missouri and the Platte, were the paths followed by settlers through the Rocky Mountains to the Oregon and California territories. Travelers usually began their long journeys at St. Louis or Independence, Missouri, outfitting towns for the west.

One route went up the Missouri River to Fort Benton, Montana, where cataracts made the river unnavigable, and then continued overland by horse or mule train. A more southerly route followed the Missouri to the Platte and then on to the Oregon or Overland Trail. The Platte is a shallow river in a low valley extending through Nebraska, Colorado, and Wyoming. This route was first used by fur trappers and, later, by explorers, military expeditions, and pioneers in covered wagons. Dangers of the overland journeys included hostile Indians and crossing unpredictable rivers such as the Cache la Poudre and Medicine Bow Creek.

At the end of the Platte River, the Oregon Trail ran through the Continental Divide via South Pass in the Wind River Range, to avoid the rough terrain in Yellowstone. The trail was thick with wagon trains of missionaries and settlers from the east and with gold seekers en route to California.

The Mormons were one of the largest groups to follow part of the trail, but they turned southwest to settle near the Great Salt Lake in Utah. Farther south, Zion Canyon is cut by the Virgin River into a gorge fifteen miles long and a half mile deep. Most others who followed the trail headed northwest from Fort Bridger, then along the Snake River to its junction with the Columbia River.

In 1858, Albert Bierstadt, destined to become the preeminent landscape painter of the American west, made his first trip to the Rocky Mountains and traveled along the Platte River through Nebraska and the Wind River through Wyoming. The paintings he created on his return were among the first real views of the American west.

Many American landscape painters had traveled to exotic settings outside the country, in Central and South America, the Arctic region, and throughout Europe. Bierstadt found exotic settings in the western United States, where, for him, the Rockies were like the Alps. He painted them in great detail, although not always true to nature. His paintings were composed, colored, and lit for the dramatic impact that the huge canvases would have on the viewer. Through Bierstadt and others, the mountains, cliffs, gorges, and precipices of the west became as popular as eastern mountain views.

Thomas Worthington Whittredge had settled in New York as part of the later generation of Hudson River School artists. He first ventured west in 1865 with fellow artists John Frederick Kensett and Stanford R. Gifford on a government inspection tour, and returned in the 1870s. His painting style may have matured during these journeys, but it retained the look of eastern landscapes in quiet scenes of forest interiors shaded from the sunlight.

In 1872, Thomas Moran accompanied photographer William H. Jackson on his second trip to Yellowstone. Here Moran found the scenery to which he could apply the principles of the great English colorist, J.M.W. Turner. The colors of canyon walls, principally yellow, but also orange and red, were enflamed by strong western sunlight, although at times diffused by the mist from the over 200 geysers and thousands of hot pools. Moran's canvases and Jackson's photographs helped convince the United States Congress in 1872 to preserve the unspoiled natural beauty of Yellowstone by making it the country's first national park.

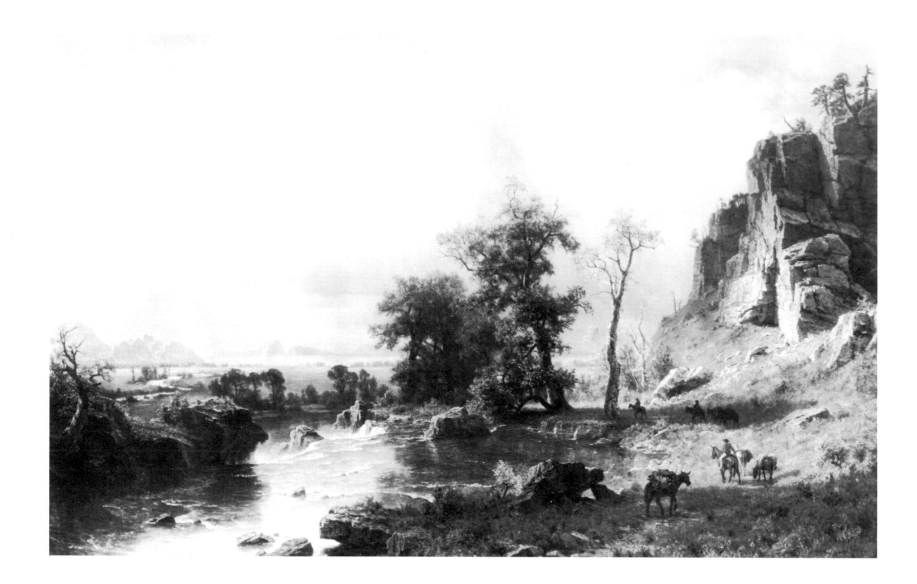

Platte River Albert Bierstadt (1830–1902)
Nebraska *Platte River, Nebraska* 1863
oil on canvas; 36 x 57½ in.
Jones Library, Inc., Amherst, Massachusetts

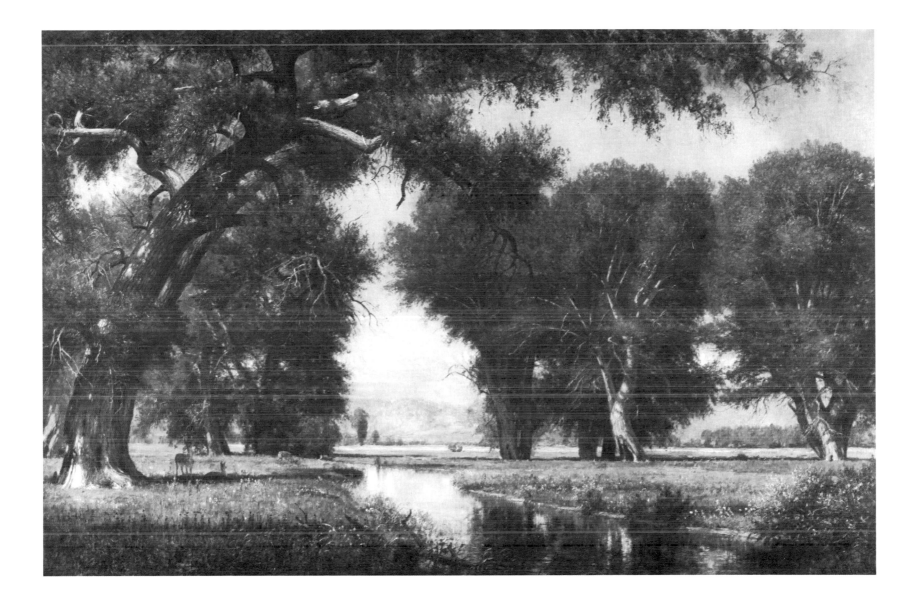

Cache La Poudre River Thomas Worthington Whittredge (1820–1910)
Colorado *On the Cache La Poudre River, Colorado* 1876
oil on canvas; 40⅜ x 60⅜ in.
Amon Carter Museum, Fort Worth, Texas

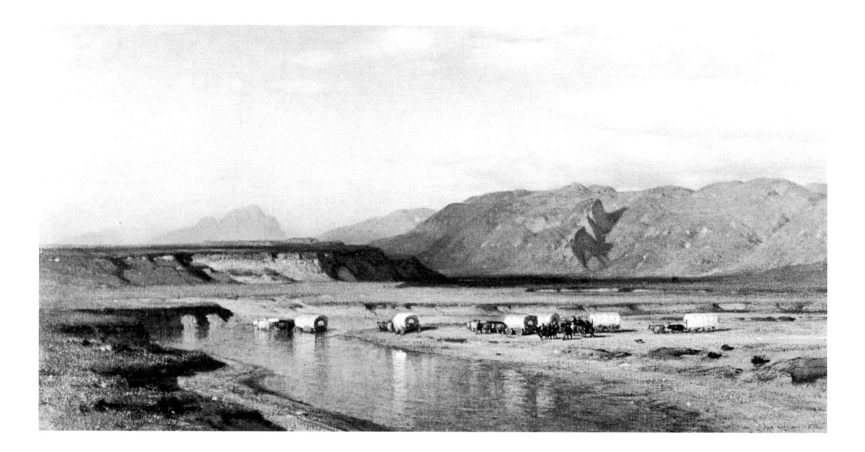

Medicine Bow Creek Samuel Colman (1832–1920)
 Wyoming *Covered Wagons Crossing Medicine Bow Creek* 1870
 oil on canvas; 16 x 30 in.
82 The Hall Farm Group, North Bennington, Vermont

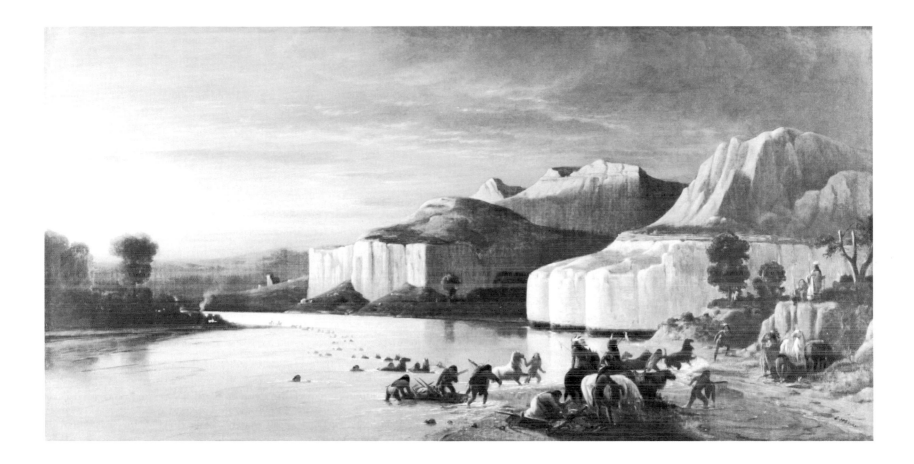

Missouri River Charles Wimar (1828–1862)
Indians Crossing the Upper Missouri 1859–60
oil on canvas; 24¼ x 48⅛ in.
Amon Carter Museum, Fort Worth, Texas

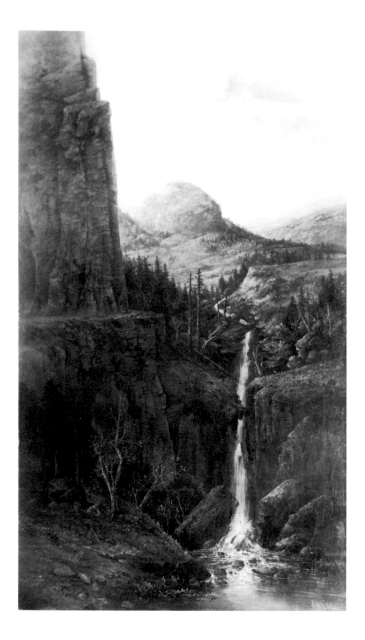

Falls Joseph Hitchins (1838–1893)
Colorado *Falls in the Colorado Rockies* undated
oil on canvas; 84 x 48 in.
Museum of Fine Arts, Museum of New Mexico, Santa Fe, New Mexico

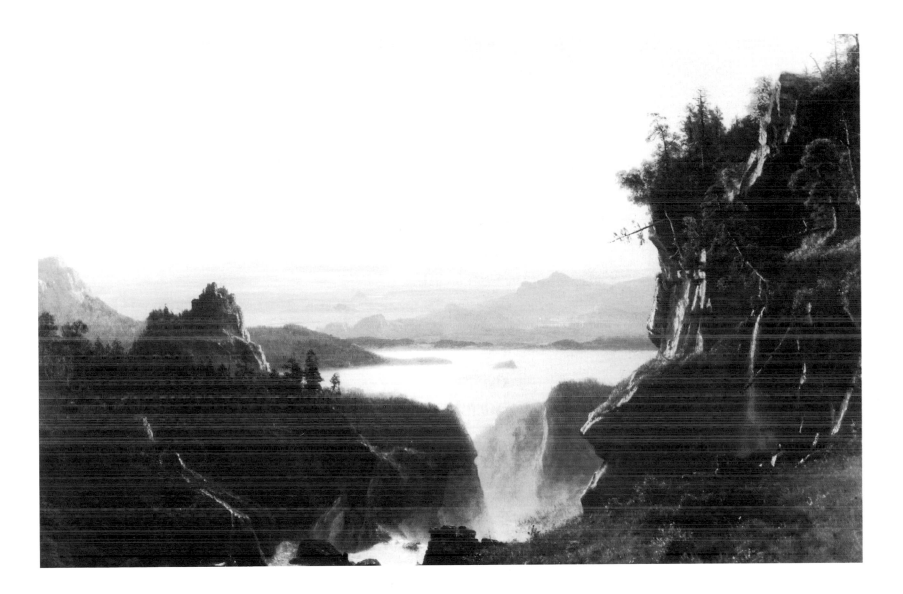

Island Lake Albert Bierstadt (1830–1902)
Wyoming *Island Lake, Wind River Range, Wyoming* 1861
oil on canvas; 26½ x 40½ in.
Buffalo Bill Historical Center, Cody, Wyoming

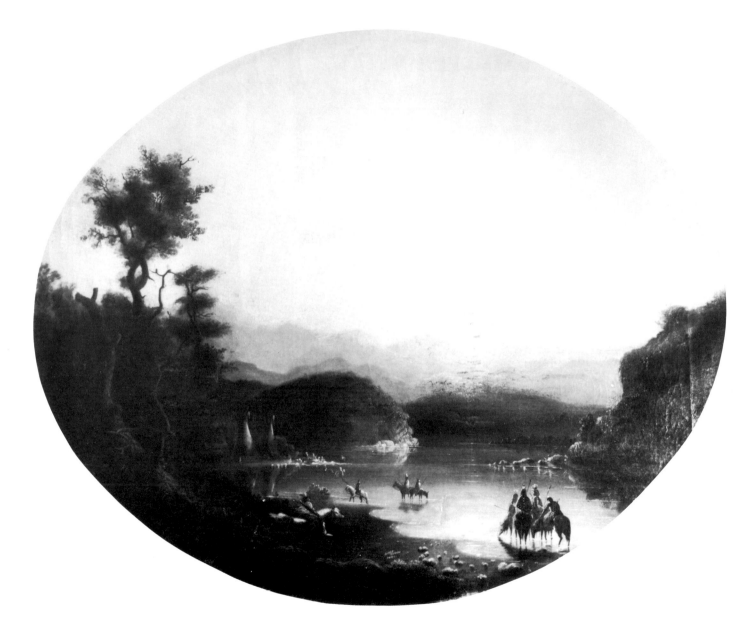

Fremont Lake Alfred Jacob Miller (1810–1874)
Wyoming *Lake Fremont* undated
oil on canvas; (oval) 28¾ x 36½ in.
The Denver Art Museum, Denver, Colorado

86

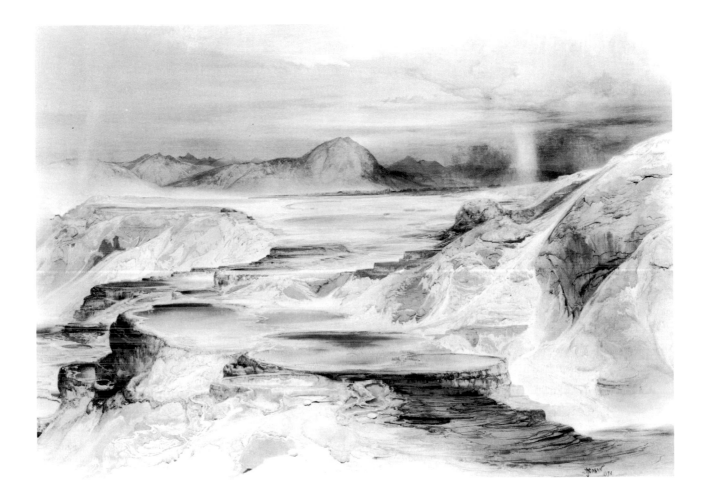

Gardiners River Thomas Moran (1837–1926)
Wyoming *Hot Springs of Gardiners River, Yellowstone National Park, Wyoming Territory* 1872
watercolor on tinted tan paper; 20¼ x 28⅝ in.
Hirschl & Adler Galleries, Inc., New York, New York

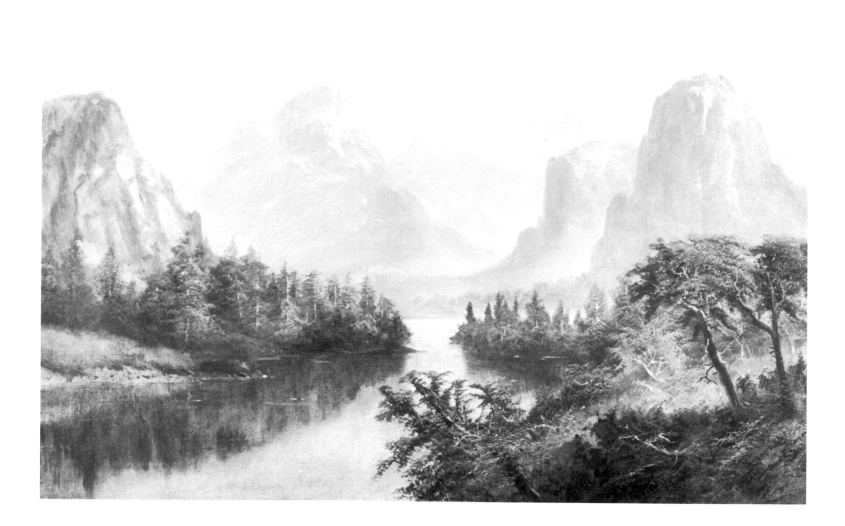

Columbia River Unknown (19th century)
Washington *Rooster Rock, Columbia River* undated
oil on canvas; 30½ x 48½ in.
IBM Corporation, Armonk, New York

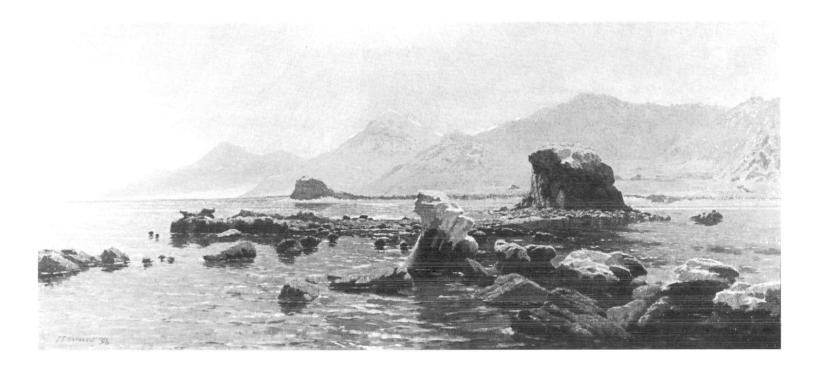

Great Salt Lake James Taylor Harwood (1860–1940)
 Utah *Black Rock* 1898
 oil on canvas; 26 x 58 in.
 Utah State Fine Art Collection, Utah Arts Council, Salt Lake City, Utah

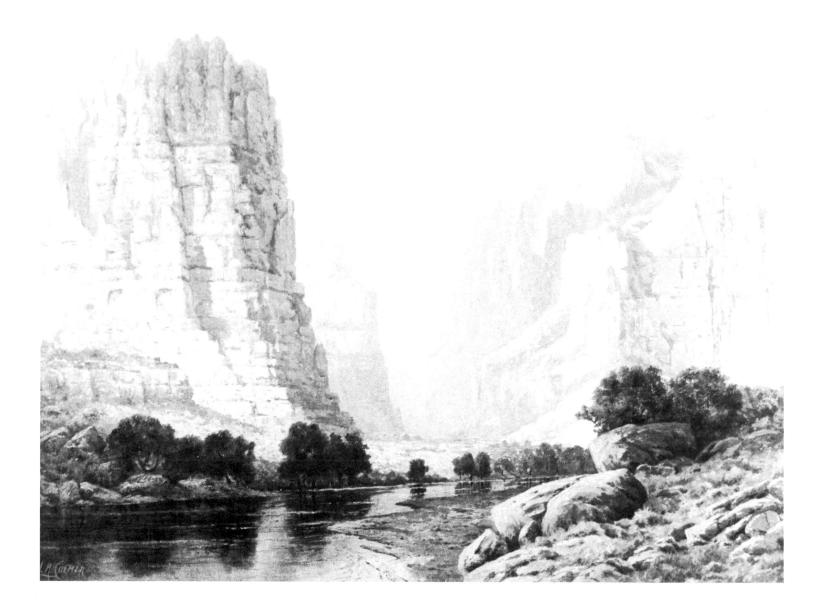

River Henry Lavender Adolphus Culmer (1854–1914)
Utah *River Scene, Zion Canyon* 1890s
 oil on canvas; 30⅛ x 39⅞ in.
 Utah State Fine Art Collection, Utah Arts Council, Salt Lake City, Utah

The Southwest, California, and Yosemite

In the arid, semi-desert southwest, rivers were a source of life for the Indians, both to support the game they hunted and to irrigate their fields. Extensive ruins left along the Gila River in Arizona are eloquent reminders of the prosperity of their culture.

Rivers were also lifelines for the Spanish as they extended the boundaries of their empire north from Mexico. Missions and forts provided a dual system of control throughout the southwest and California. When Mexico gained its independence from Spain in the early nineteenth century, it claimed these sparsely settled borderlands, but lost Texas, New Mexico, and California to the United States in 1848.

American settlers flooded the newly acquired lands. Farmers were particularly attracted by such areas as the hill country of Texas, whose clear rivers brought in thousands of German settlers and that state's first landscape painter, Hermann Lungkwitz.

More important than farmland in consolidating American control of the new area, however, was "gold rush fever." Shortly before peace was concluded, a worker discovered gold at Sutter's Mill, California. Thousands of gold seekers moved west in 1849, transforming San Francisco from a small village to a full-fledged city and vastly increasing the American population throughout the west.

A few years later, in 1851, a United States Army battalion discovered a beautiful valley while rounding up Indians suspected of raiding the mining communities on the Sierra slopes. One of the clans of the tribe living there was called the Uzumati, from which was derived the valley's present name, Yosemite. Its location, only 150 miles east of San Francisco, brought many tourists to wonder at Half Dome, Glacier Point, and the beautiful canyons and waterfalls made by the Tuolumne, Merced, and Yosemite Rivers. The Yosemite Valley, seven miles long and a mile wide, is only a small part of the national park that covers 790,000 acres in the Sierra Mountains.

The great panoramic views of the Yosemite Valley inspired large canvases by artists traveling through the west. Such picturesque scenery appealed to popular tastes, and engravings made from paintings by Albert Bierstadt, Thomas Hill, and William Keith and from photographs by Timothy O'Sullivan and William H. Jackson sold widely.

Bierstadt had traveled to California in 1863 with the journalist Fitz Hugh Ludlow and returned to his castle-like studio at Irvington-on-the-Hudson, New York, where he painted melodramatic canvases. For Bierstadt and his contemporaries, Hill and Keith, the scenery depicted often departed from the visions they had seen in their explorations. Since what they had experienced on the trail would be nearly impossible to translate literally into a painting, they exaggerated the scene to dramatize certain passages. Their ambition was to communicate the sensation of natural wonders and to induce the viewer, when confronting the painting, to feel that his next step forward would bring him into the picture with the deer and Indians who sometimes occupied the foreground.

The drama of these paintings is quite different from those of the Hudson River artists in the east, since the artists in the east were painting the scenery of their birth, and the artists of the west, a setting newly opened to the eyes of civilization. All had preserved in painting the American landscape in its original, unspoiled purity.

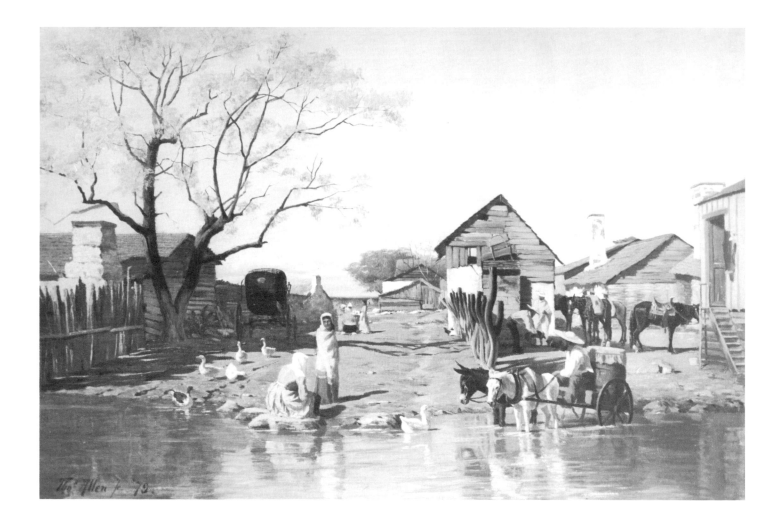

San Pedro Spring Thomas Allen (1849–1924)
Texas *Old San Pedro Ford* 1879
oil on canvas; 18 x 26 in.
92 San Antonio Public Library System, San Antonio, Texas

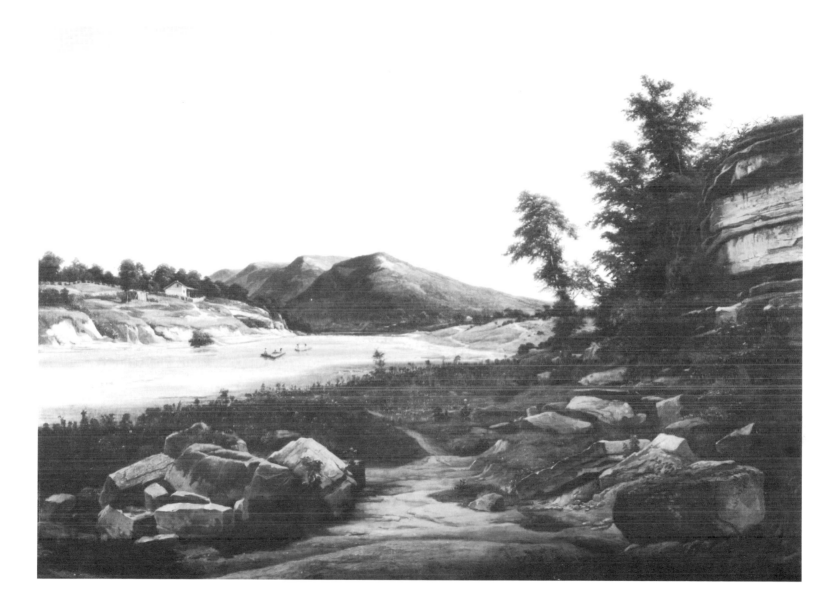

Pedernales River Hermann Lungkwitz (1813–1891)
Texas *Hill Country* 1875
oil on canvas; 26 x 36 in.
San Antonio Museum Association, San Antonio, Texas

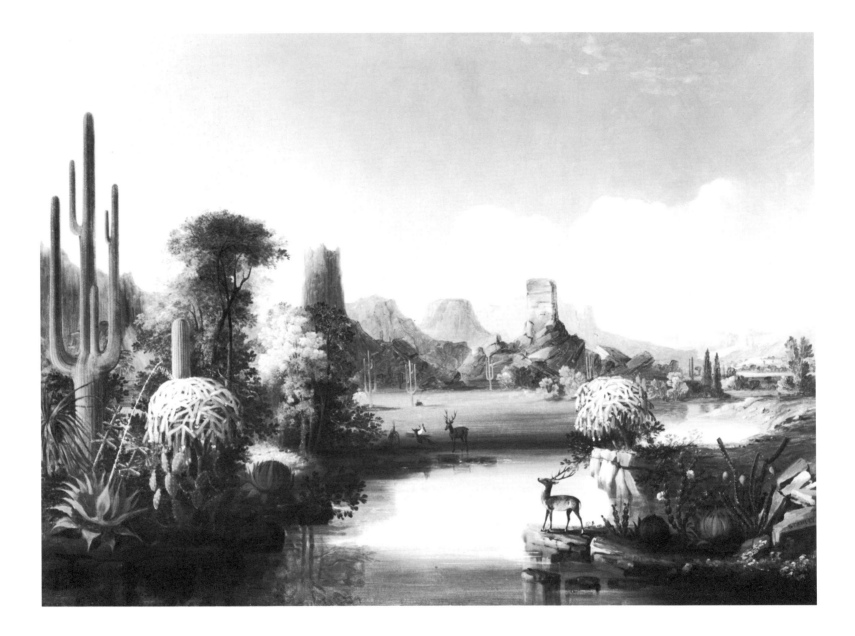

Gila River
Arizona or New Mexico

John Mix Stanley (1814–1872)
Chain of Spires along the Gila River 1855
oil on canvas; 31 x 42 in.
Phoenix Art Museum, Phoenix, Arizona
Museum Purchase

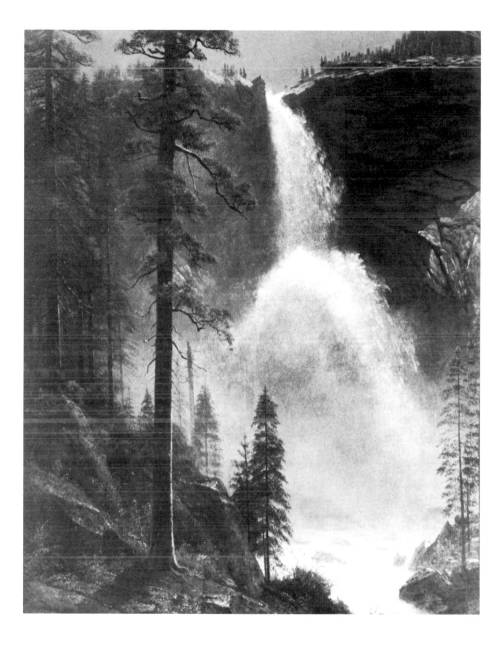

Nevada Falls Albert Bierstadt (1830–1902)
California *Nevada Falls, Yosemite* ca. 1865
 oil on board; 24 x 18 in.
 Everson Museum of Art, Syracuse, New York
 Museum Purchase, 1976

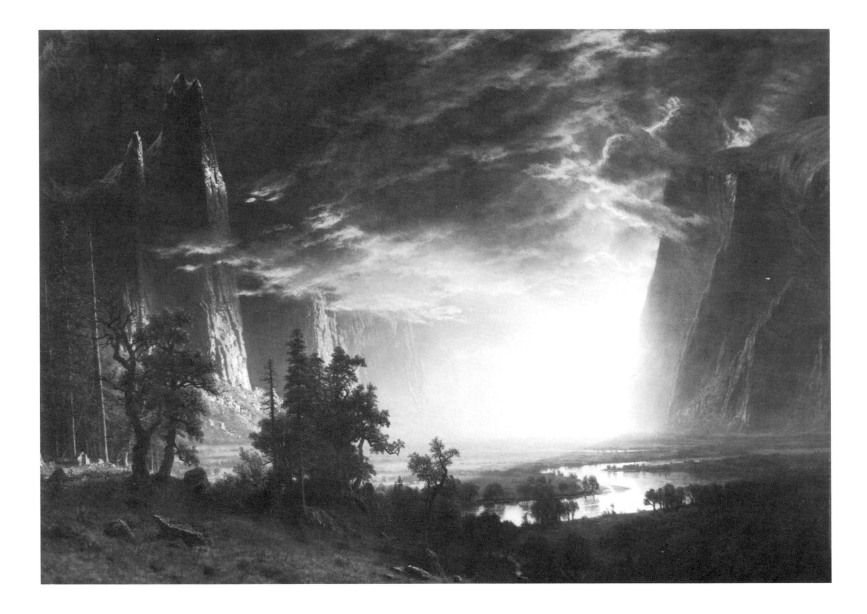

River Albert Bierstadt (1830–1902)
California *Sunset in the Yosemite Valley* 1868
oil on canvas; 35½ x 51½ in.
The Haggin Museum, Stockton, California

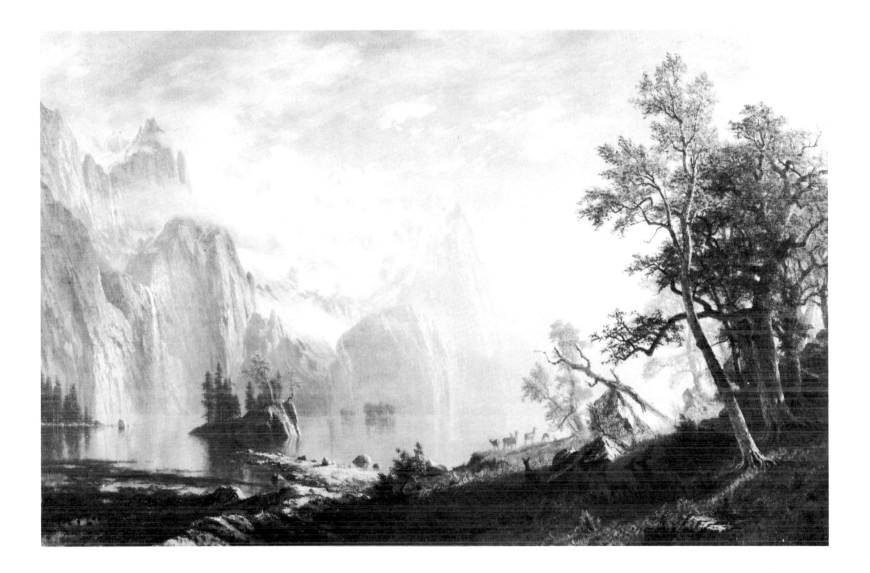

River Albert Bierstadt (1830–1902)
California *Western Landscape* 1869
oil on canvas; 36¼ x 54½ in.
The Newark Museum, Newark, New Jersey

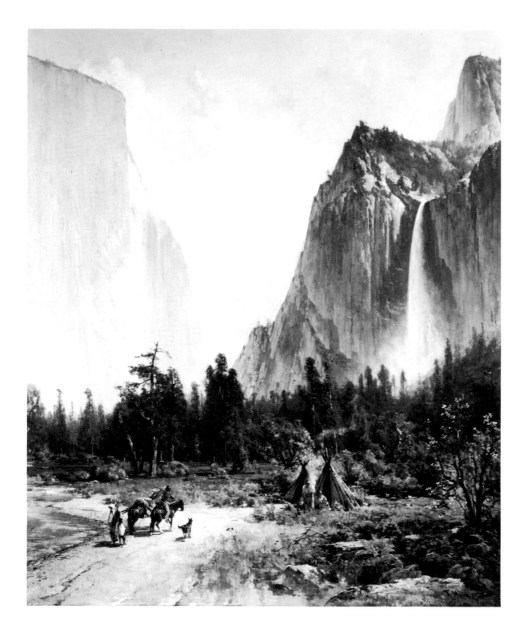

Bridalveil Falls Thomas Hill (1829–1908)
 California *Yosemite Valley (El Capitan and Bridal Veil Falls)* undated
 oil on canvas; 88 x 72 in.
 The Oakland Museum, Oakland, California
98 Bequest of Dr. Cecil E. Nixon

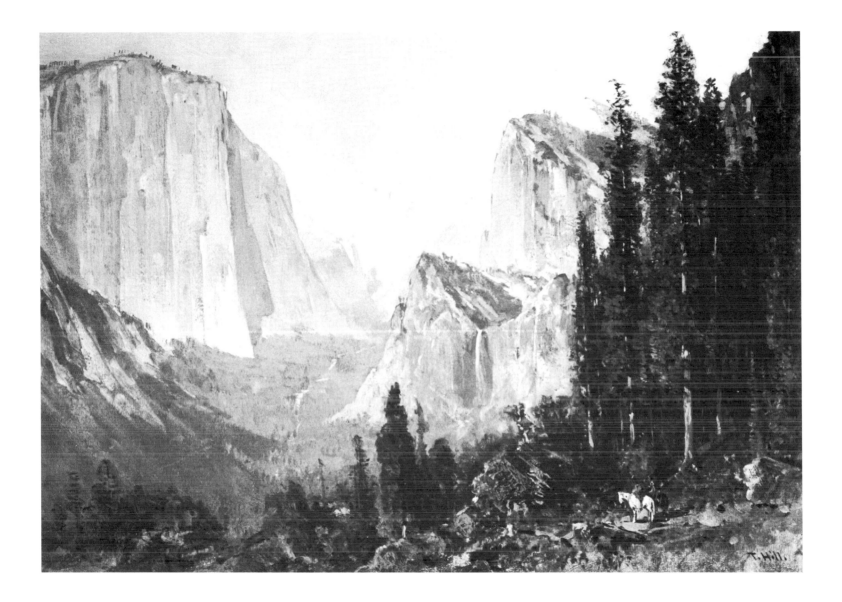

Bridalveil Falls Thomas Hill (1829–1908)
California *Yosemite Valley–Bridal Veil Falls* ca. 1890
oil on canvas; 17 x 24 in.
California Historical Society, San Francisco/Los Angeles, California

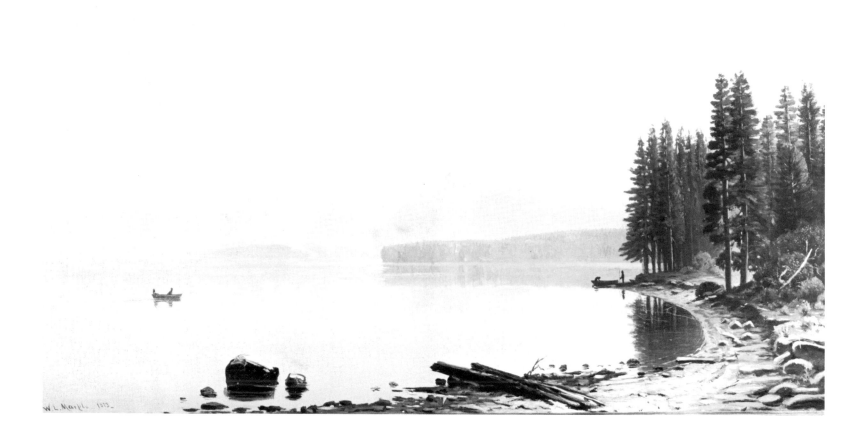

Lake Tahoe William L. Marple (1827–1910)
California *Lake Tahoe* 1873
 oil on canvas; 19^{11}/$_{16}$ x 36 in.
 Crocker Art Museum, Sacramento, California
100 Gift of Mrs. J. L. Wintle

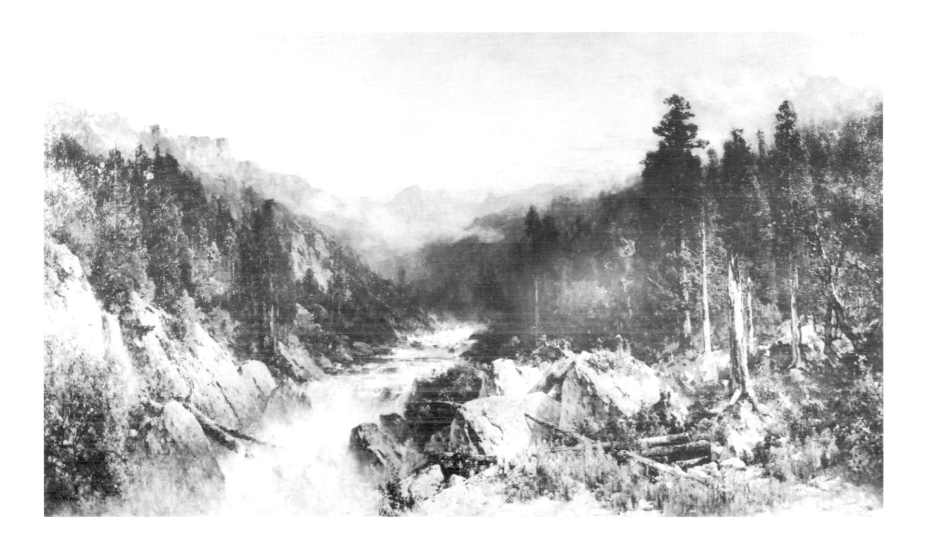

Mill Creek Thomas Hill (1829–1908)
California *Mill Creek Canyon* undated
oil on canvas; 48¾ x 84¼ in.
Crocker Art Museum, Sacramento, California

Index of Artists

John A. Mahé II, Exhibition Coordinator
Lisette C. Oser, Exhibition Registrar

with the assistance of

THNOC Staff

Dode Platou, Chief Curator
Rosanne McCaffrey, Curator
John H. Lawrence, Curator
Patricia Brady Schmit, Director of Publications
Gail Larsen Peterkin, Publications Assistant
Tom Staples, Head Preparator
Priscilla D. O'Reilly, Registrar
Maureen Donnelly, Assistant Registrar
Joan L. Lennox, Research
Howard Estes, Site Manager
Susan R. Laudeman, Director of Shops
Jan White, Head of Photography

NOMA Staff

William A. Fagaly, Assistant Director of Art
Daniel Piersol, Registrar
Paul Tarver, Assistant Registrar
Virginia Weaver, Publicity

THE WATERS OF AMERICA

19th-Century American Paintings of Rivers, Streams, Lakes, and Waterfalls

This book was set in Caledonia,
which was designed in 1938 by W. A. Dwiggins,
one of America's foremost type designers.

The book was designed by Michael Ledet,
Word Picture Productions, New Orleans.

Typography and production were done by
Impressions, Inc., Madison, Wisconsin.